STOLEN MOMENTS THE PHOTOGRAPHS OF RONNY JAQUES

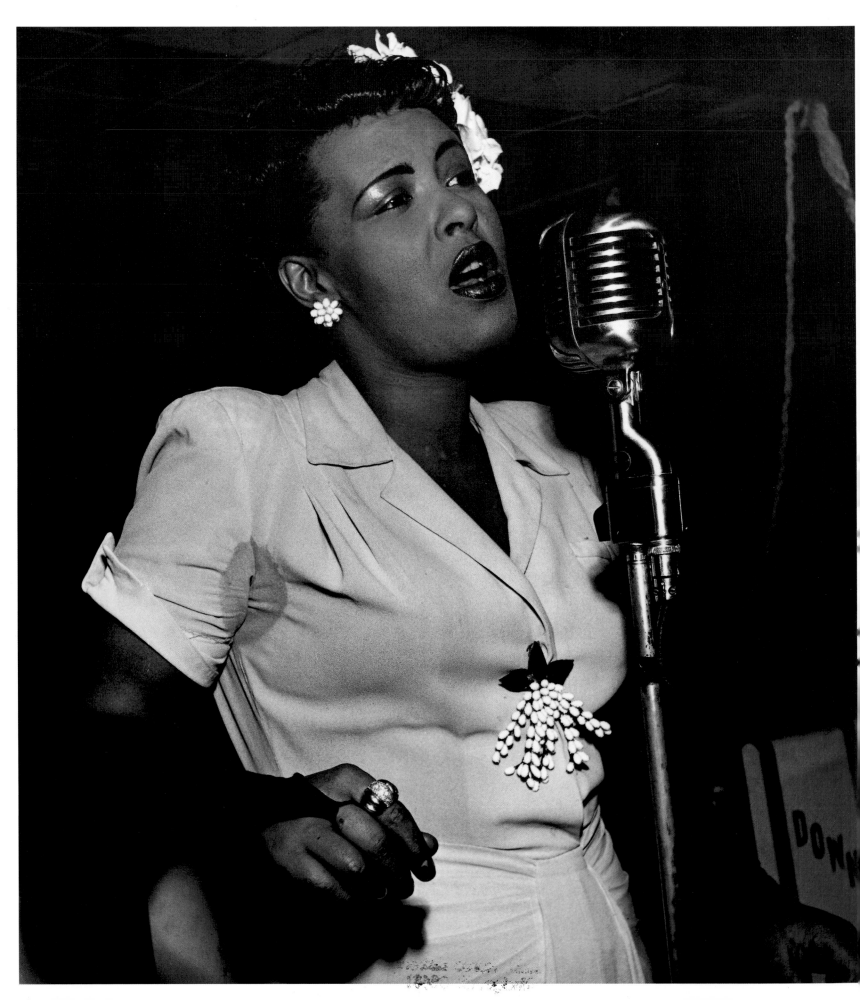

STOLEN MOMENTS
THE PHOTOGRAPHS OF RONNY JAQUES

PAMELA FIORI

Glitterati
INCORPORATED

NEW YORK, NEW YORK

Design by Mary Shanahan

Typographic design by Agnethe Glatved and Frank Augugliaro

First published in the United States of America
in 2008 by Glitterati Incorporated

Glitterati
INCORPORATED
NEW YORK, NEW YORK

225 Central Park West, suite 305
New York, New York 10024
www.GlitteratiIncorporated.com

Second edition, 2009

Library of Congress Cataloging-in-Publication data
is available from the publisher

Hardcover ISBN 13:978-0-9801557-2-3

Printed and bound in China by Hong Kong Graphics & Printing Ltd.

10 9 8 7 6 5 4 3 2

Frontispiece: Jazz singer Billie Holiday,
Downbeat Club, New York, 1943

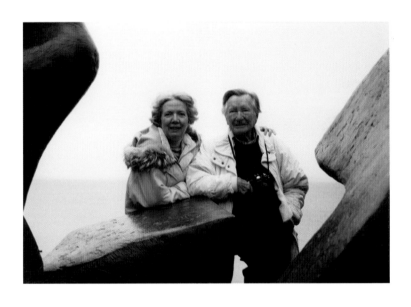

TO DEAR RONNY, WHO KNEW NO EQUAL, AND TO HIS DARLING WIFE, LISE.

INTRODUCTION

IN MAY 1982, when I was on my honeymoon, an extraordinary man named Ronny Jaques came into my life. If this sounds a little odd, let me quickly add that my husband feels about him as I do. If the name doesn't ring any loud bells, I'm not surprised. Ronny Jaques went about his work quietly, modestly, deliberately and without fanfare. Nonetheless, he is one of the greatest, most prolific magazine photographers who ever was.

His heyday was in the 1940s, 1950s and 1960s, when he shot mostly for *Harper's Bazaar, Junior Bazaar* (which lasted less than three years, from 1945 to 1948), *Town & Country* and *Holiday.* In his later years, he became the chief travel photographer for *Gourmet* magazine.

When he started out, there wasn't much Ronny couldn't or wouldn't do: celebrity portraits, fashion portfolios, travel features, society stories and serious reportage. He was drawn to people in the arts—ballerinas, stage actors, writers and poets, classical and jazz musicians, composers and conductors—and they were drawn to him. How could they not have been? Ronny was a charmer. He also knew how to be inconspicuous.

To be a magazine photographer in the twenty-first century is to be the lead horse in a team. Going it alone is almost unheard of. At the very least, you need a willing and hopefully able assistant—a Sherpa of sorts, who will carry the equipment, change the lenses, adjust the tripod, do the legwork and fetch the coffee. If the assignment is a fashion shoot, the duo could easily grow into a virtual village (not that it takes one, mind you) of specialists: models, fashion editors, hair and makeup people, assistants to the assistants and so on. Not only is it a huge and complicated production, it's also an expensive one.

Ronny Jaques (pronounced "Jakes") would have none of that. He was a one-man show, doing everything by himself and for himself, and thought the entire idea of having a crew was preposterous. "I never had an assistant," he once told me. "I didn't feel I could trust a system that would let anyone else do it. I was young. It was no sweat. You don't want to carry too much baggage. It gets in the way."

Traveling light was Ronny Jaques's modus operandi. As a photographer, Ronny did it all: He took the pictures; he often chose the people to shoot; if it was a fashion story, he picked out the clothes; he changed the film and switched the lenses. He even took notes to be used as research for the story and the photo captions. For a while, he also did his own printing, then reluctantly turned that part over to a company in Manhattan that, wouldn't you know it, lost all of his black-and-white negatives.

Being on his own had its advantages: He could slip in and out of situations easily and quickly. His subjects readily warmed to him and opened up because he was good company and knew how to put people at ease. He could drink with the best of them (although, admittedly, not as much) and was often invited to share a meal at the end of the shoot—try that with a cast of twelve or fourteen. This sense of intimacy was definitely an asset, and no one understood this better than Ronny Jaques.

Sometimes he traveled on assignment with the writer or the magazine's top editor (mostly for company). But no one got in each other's way. That was the tacit understanding.

Ronny Jaques was born in England in 1910. His father was a bookmaker—a legitimate business in Britain—but along the way became entangled in some dubious activities. He was run over by a train in the London Underground, which Ronny believed might not have been an accident. "Scotland Yard got after him, so he may have committed suicide." That left Ronny, his mother and his brother, Louis (almost three years older) adrift.

During World War I, Ronny went to boarding school in a coastal town on the Thames. "Every night, there would be an air raid and we'd have to go down into the basement of the school." To avoid the air raids, the school was moved to Bedford, in the middle of England. "It was a land of big fields with horses. I can still see it." There he stayed until war's end.

"Mom closed up Dad's business and moved us to Christie Lake in Canada. I was nine at the time. We arrived in Perth in the late fall. Jesus, it was cold, but I loved those years. The school was a mile away,

Actor Robert Mitchum,
New York, 1947

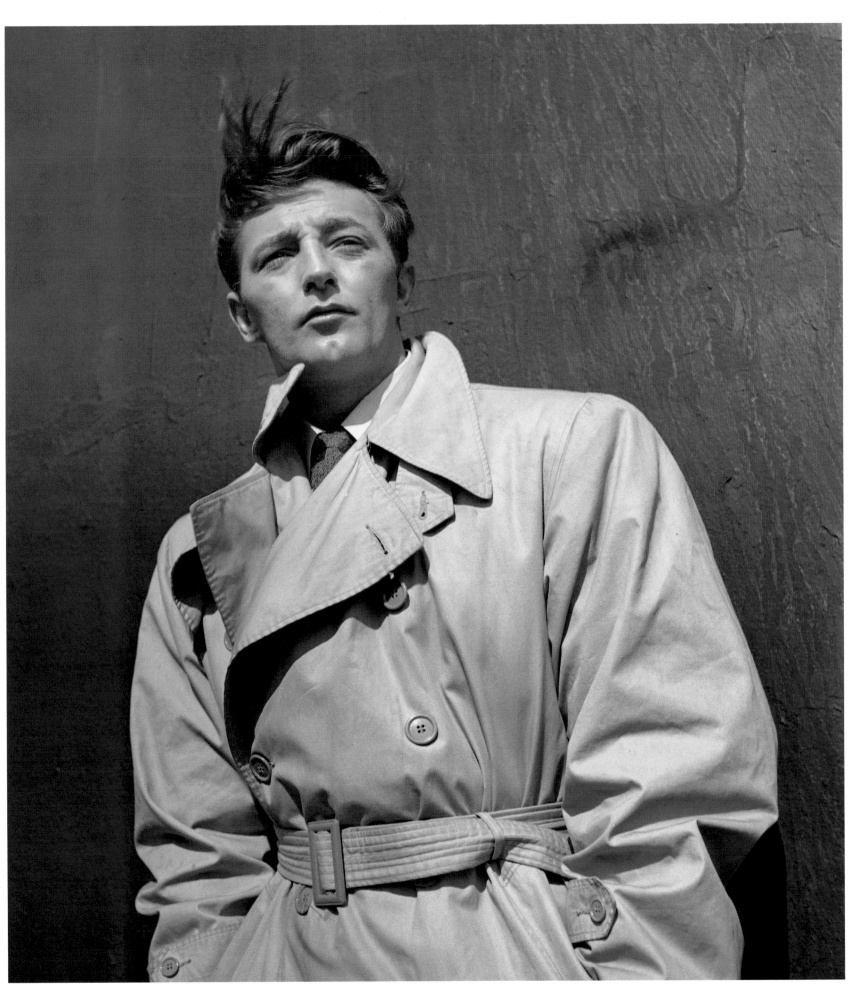

and I would get a ride on the runners of one of the sleighs. In spring, we would go into the woods and draw maple syrup. We had just enough money to live, but live we did," Ronny recalled.

By the time they were in their teens, Ronny and Louis went to New York, where Ronny found a job through an employment agency as a runner on Wall Street. "I was only fourteen years old," Ronny remembered. This was in 1924, before the Crash. By 1929, when the Crash occurred, he was working for Henry L. Dougherty, the founder of a gas company, taking care of customer complaints.

While Ronny worked for Dougherty, Louis had a job as a bank teller. Because they both had accumulated a fair amount of money in overtime, they decided to quit their jobs in 1932 to go bicycling in Europe.

"I don't think we had a bath in two years. It cost us fifty dollars a month to live, to eat and occasionally go to the opera. We had a wonderful experience, but I knew it was time to get serious. 'I think I'll see if I can become a photographer,'" Ronny said to himself, just like that. "Up to that point, I'd been fooling around with a little Kodak camera called a Hawk-Eye."

Ronny enrolled at the Regent Street Polytechnic in London and stayed there for eight months to learn his craft. "Afterward, I decided I needed experience in a studio and became an assistant to a photographer on Savile Row for two or three months." Ronny, however, was eager to go off on his own and arranged to open a studio in Canada. He had just enough money to do that, but not enough to get him there. Through a friend whose father was head of a cargo ship company, he was able to get passage for himself and Louis on a four-thousand-ton coal boat. "I was hired as the purser and Louis as the assistant purser. However, since it was a cargo ship, there were no passengers." It was all a ruse. But they paid their dues. "It was the roughest goddamn voyage. The captain was drunk from the moment we left until thirty days later, when we arrived in Canada."

He opened the Ronny Jaques Studio at 24 Grenville Street, in Toronto. "I taught Louis to run the darkroom, and we started doing portraits, stories for Canadian magazines, a little advertising and some assignments for the Canadian Film Board." When the Film Board approached Ronny to become staff photographer in 1941, the brothers closed the studio. By that time, Ronny had become fixated on a career in New York ("I wanted to be with the big boys").

It was the legendary *Harper's Bazaar* editor Carmel Snow who got him there in the mid-1940s. Impressed by his portfolio, she invited him to New York to join the *Bazaar* stable, which included such luminaries as Louise Dahl-Wolf, Richard Avedon and Lillian Bassman. Ronny was guaranteed four pages a month at $150 per page. "Not a fortune, but enough to keep me from being a ward of the state." The *Bazaar* days were heady ones for Ronny. Not only did he photograph—in black and white—for *Harper's Bazaar,* he also contributed to *Junior Bazaar,* its new publication aimed at younger readers. He was with the poet W. H. Auden on the day he became an American citizen. He took director Stanley Kramer to Spanish Harlem, actor John Mills into Central Park and lured Bette Davis and her dog to New York's dockyards. He also shot fashion stories, most of them for *Junior Bazaar.*

Ronny's career flourished at *Harper's Bazaar,* but as often happens with contributors on contract, a certain ennui sets in on one side or the other. Ronny saw his assignments lessened over time. As they did, his frustrations grew. Besides, he needed to make a living.

He didn't have to look far for another outlet. He found it at *Town & Country.* Like *Bazaar, T&C* was owned by the Hearst Corporation and located in the same building on Madison Avenue and East Fifty-sixth Street. Ronny had gotten to know some of its editors, including the one whose name was at the top of the masthead, Henry Sell. Sell was a man of strong will and definite ideas—and he definitely wanted Ronny, whose stint at *T&C* began in the 1950s and lasted for nearly twenty

years. Although Ronny was known for his fashion and personality profiles, his experience at *Town & Country* gave him a chance to expand his travel reporting, his coverage of gentlemen's sports and of high society—first under Sell and later, under his successor, Anthony Mazzola.

After a while, Ronny felt the urge to spread his wings beyond Hearst (no wonder photographers are among the world's most peripatetic creatures). He landed on the pages of *Holiday*, the most prominent travel magazine of its day. It was there, under the editorship of Ted Patrick and art director Frank Zachary, who later became editor in chief of *Town & Country*, that Ronny did some of his finest work in color. He wasn't on *Holiday*'s staff, so for a man who had, by then, been married twice and had a child, he needed a semi-regular gig. He got one at *Gourmet*, with its editor in chief Jane Montant, until he retired in 1992, at age eighty-two. Weary of fashion photography and not especially fond of the increasing population on photo shoots, he was happy to be with *Gourmet*, able to do what he did best: work alone. Sometimes, he would travel with Montant, who acted as his navigator, but she was smart enough to stay out of his way—often sitting in the car knitting while he was shooting.

Actress Bette Davis, New York piers, 1947

When my husband and I met Ronny in 1982, on our aforementioned honeymoon, he and Jane Montant were having lunch at a lovely hotel in Fiesole, outside of Florence, called the Villa San Michele. Recognizing the formidable Mrs. Montant, I gathered my courage, walked over to their table and introduced myself (something I never would have done in New York, but I was on my honeymoon and the usual rules did not apply). The four of us immediately connected and ended up having a pleasant after-lunch conversation. We continued it a few days later at the Hotel San Pietro, in Positano, which was coincidentally the next destination for all of us. It was there that Ronny and I forged our friendship, more than a quarter of a century ago, which lasted until his recent death.

After Jane Montant retired in 1991, Ronny remained at *Gourmet* under her successor, but not for long. By that time, he was living in Copen-

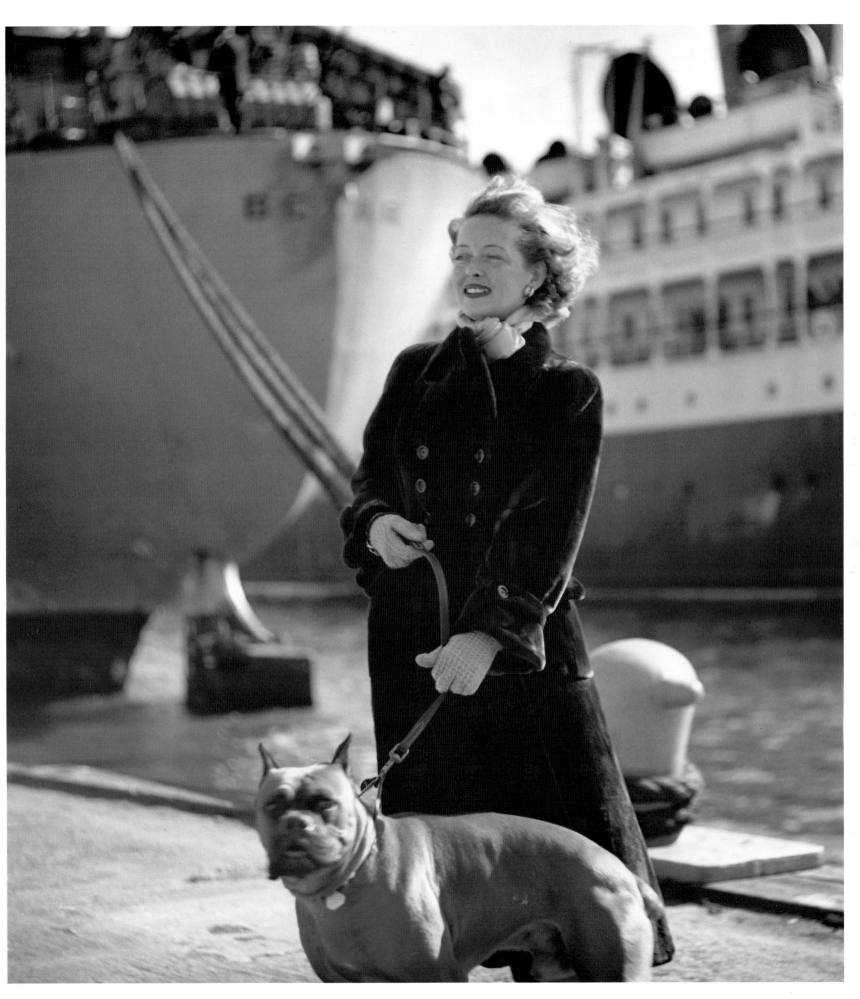

hagen with Lise, his third wife, and their two children, Lulu (married, with four children) and Jens-Louis. Josephine, his daughter from his second marriage, resides in Geneva with her son.

All of what you will see in *Stolen Moments* is in black and white. Had color negatives or prints been available, they would have been included. But much of Ronny's color work mysteriously disappeared on the watch of *Holiday*'s photo editor. It was an incalculable loss.

Still, what we have here is a treasure trove chosen from his years at *Harper's Bazaar, Junior Bazaar* and *Town & Country*. It is not everything, by any means, but it is a solid representation of Ronny's golden days. One of his first big assignments for *Town & Country* took him and a writer to Ireland, where he photographed some of its most lauded people—artists and writers primarily. While there, however, he was also taken by the country's unknowns—children playing soccer or ring-around-the-rosy, workers on their way home, ordinary citizens. One in particular, of a tinker's daughter, almost tells its own story. "This is one of my favorite photos," Ronny wrote to me. "It was taken years ago on a country road in Ireland. Somehow the child is so elegant in front of her movable home. She haunts me."

Ronny's fashion photography, featuring beautifully groomed models dressed in the pretty, proper clothes of the 1950s, was of its time, with one difference: the women were often looking away from the camera, not into it. They are similar to his portraits, which are intense and reflective. It is almost as if the subjects had been caught off-guard (although Ronny would have been the first to tell you that there was nothing off-guard about them; each frame was carefully composed). It's why we decided to call this book *Stolen Moments*, which is also the title of a soulful tune written in 1961 by jazz saxophonist Oliver Nelson. As for the image on the cover, there was no question as to which of his photographs it would be: the one of Marlon Brando, taken in the *Harper's Bazaar* studio in 1947. Brando was appearing on Broadway in the role

he made famous—that of Stanley Kowalski in Tennessee Williams's *A Streetcar Named Desire.* As Ronny told it, when he entered the studio, he noticed—barely—a young undistinguished-looking man in a dark T-shirt unassumingly sitting on a bench. Thinking he was a messenger, Ronny brushed past him. He waited for a while, then finally walked out in the reception area and asked the receptionist if anyone had showed up named Marlon Brando. She nodded toward the young man. Ronny ushered him into the studio, asking if he'd mind bringing the bench along with him. He situated the shot in such a way that it permitted just enough daylight to pour in and capture the charismatic Brando, curled up like a cat, at once virile and vulnerable. Of all of Ronny's portraits, it remains my favorite.

It was a privilege to be able to spend so much time with Ronny, his family and with his repertoire in the course of creating *Stolen Moments.* It's been equally a privilege to collaborate with Mary Shanahan, who designed the book so skillfully and sensitively. Having worked closely with Richard Avedon for several years, Mary is no stranger to gifted photographers. Like my relationship with Ronny, mine with Mary—who has been the creative director of *Town & Country* since 1995—is characterized by mutual admiration, trust and deep affection. And though she and Ronny never met, Mary demonstrates an understanding and respect for the man and his work that is evident on every page of *Stolen Moments.* This book is as fine and fitting a tribute that anybody could pay to one as richly deserving as the inimitable, adorable and immensely talented Ronny Jaques.

PAMELA FIORI

OPPOSITE
A tinker's daughter girl, Ireland, 1948

PAGES 18–19
Boys playing soccer behind Merrion Square, Dublin, 1948

PAGE 20
Model, 1940s

PAGE 21
A country road, Ireland, 1948

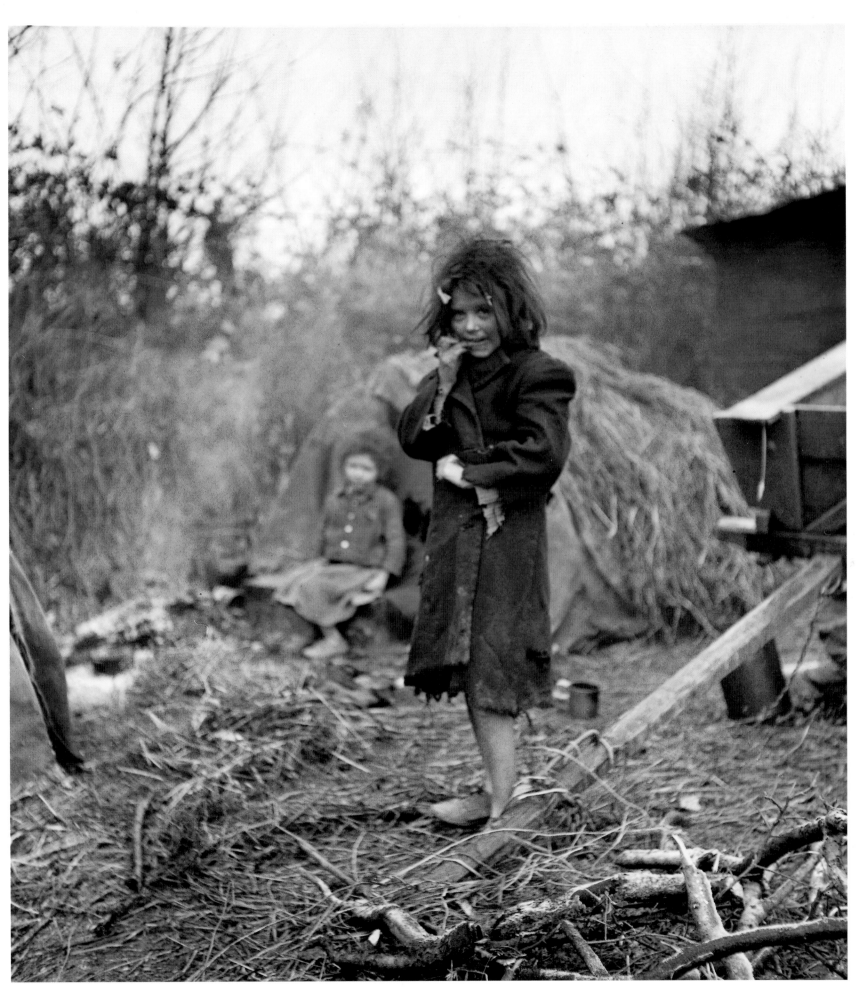

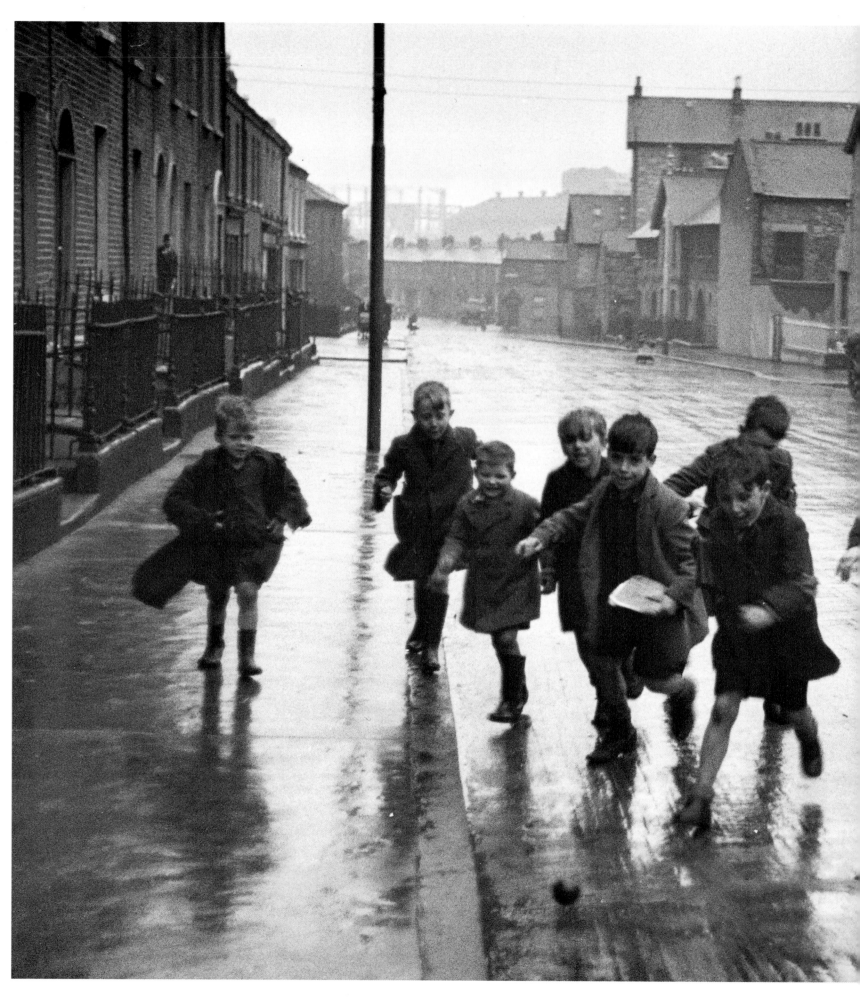

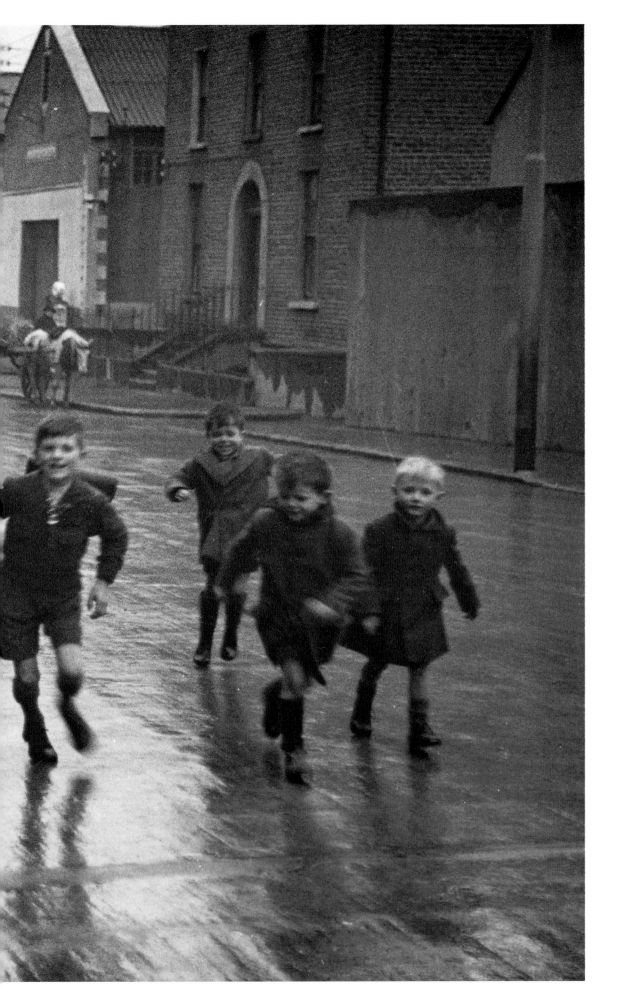

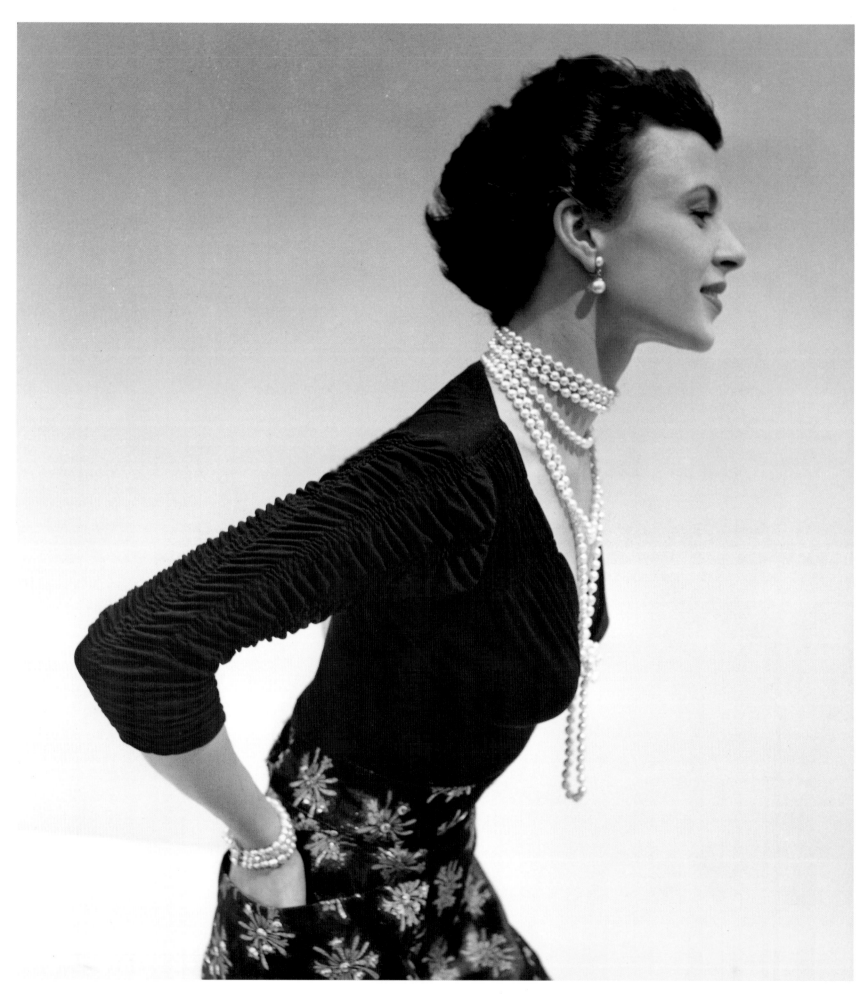

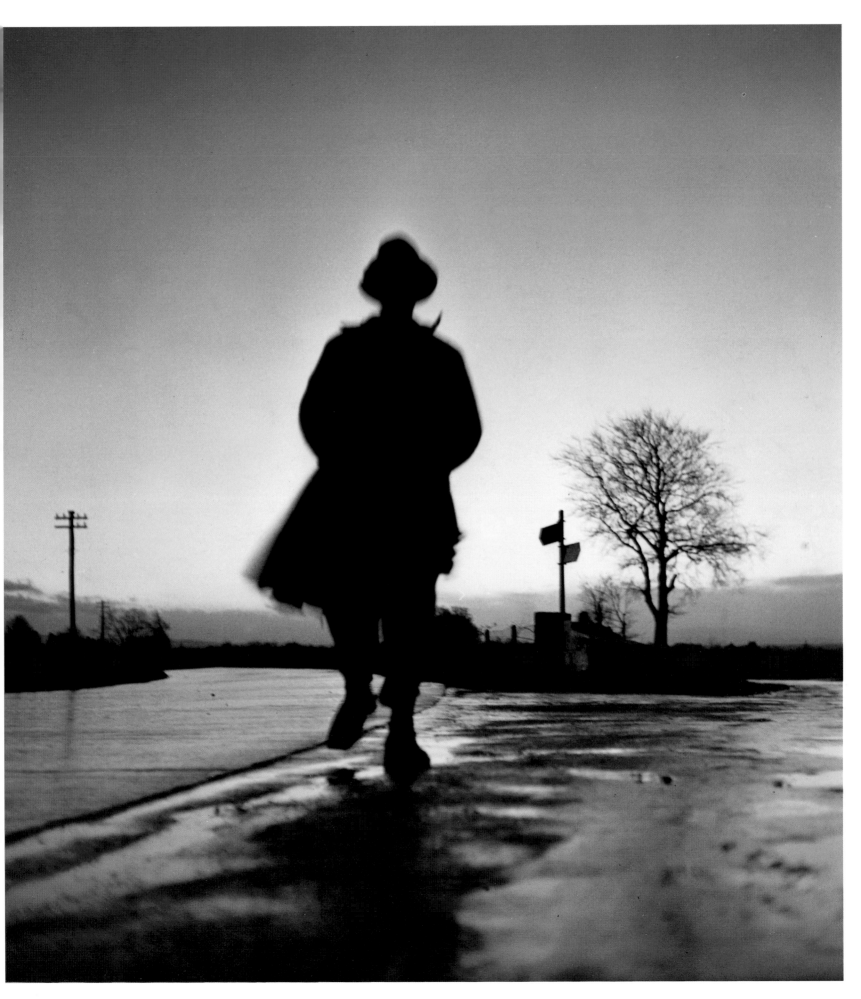

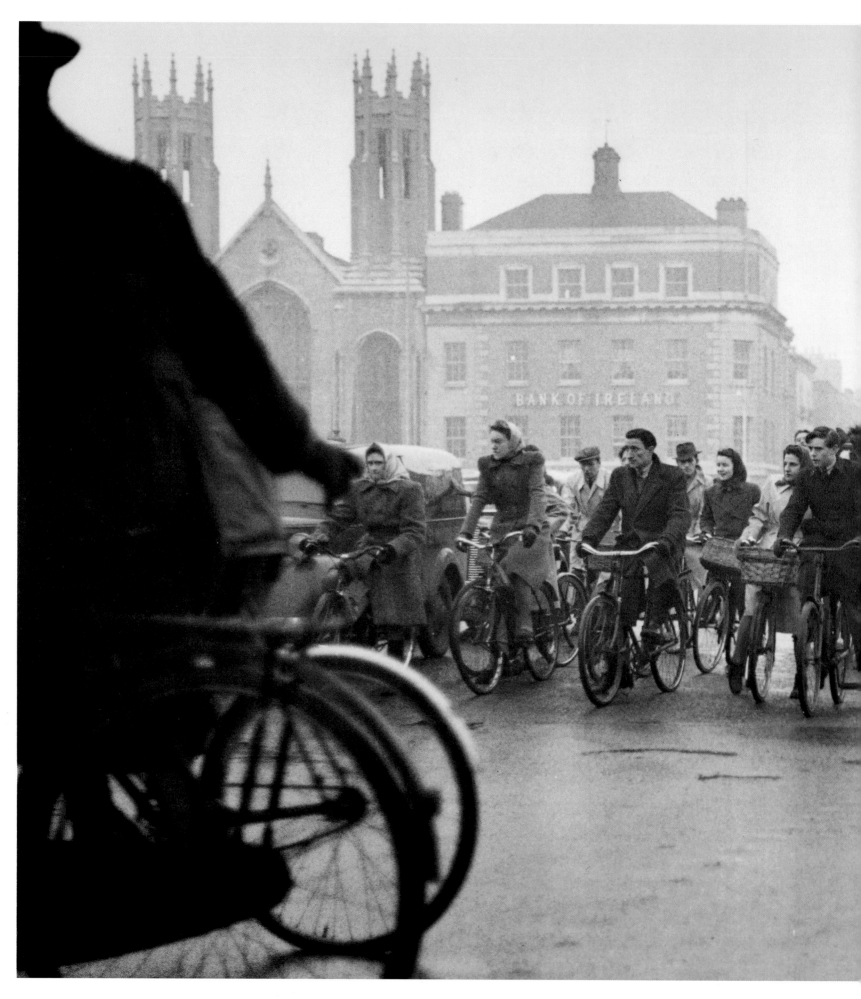

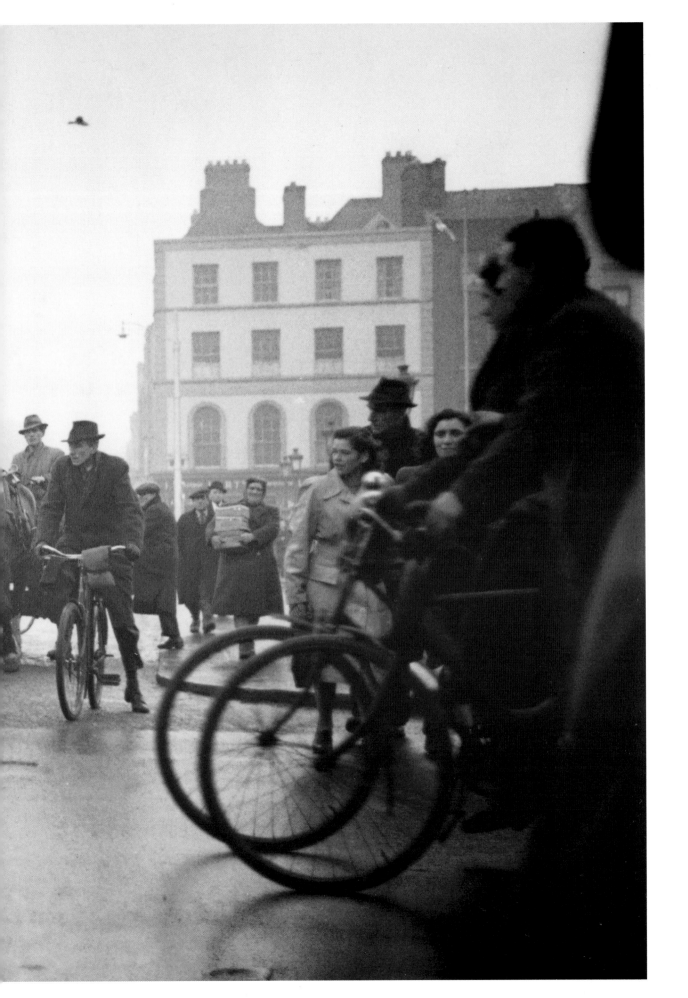

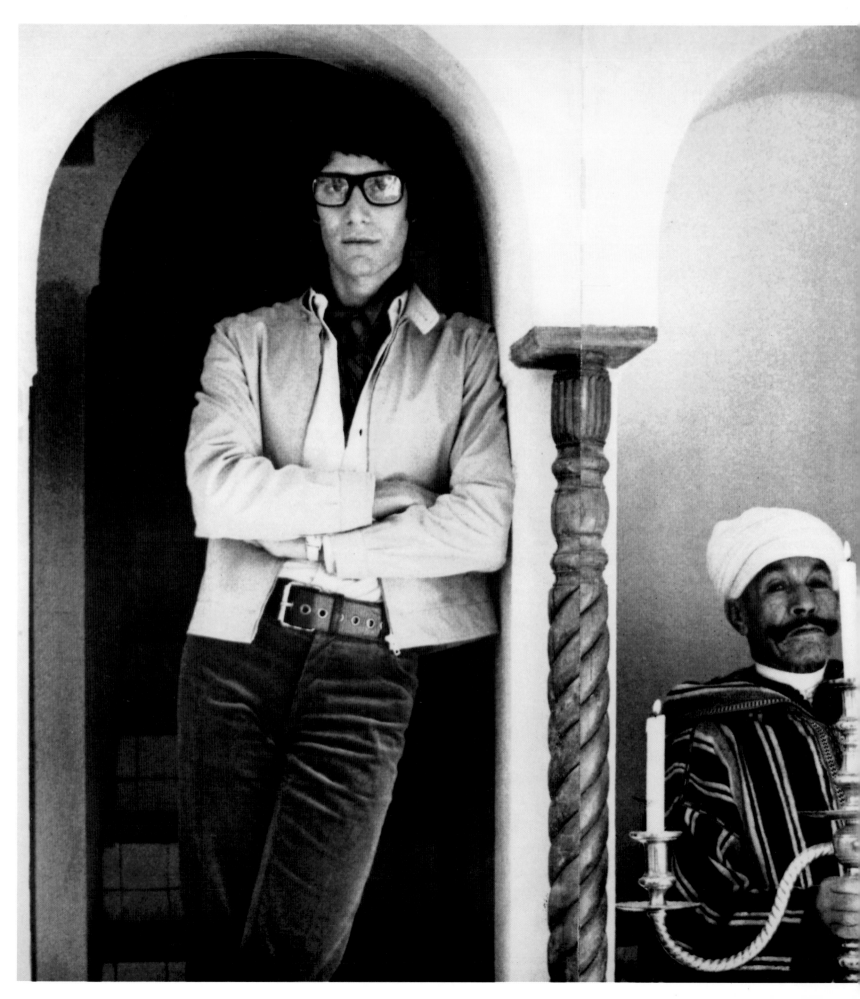

PAGES 22–23
Traffic jam of bicycles, Ireland, 1948

OPPOSITE
Couturier Yves Saint Laurent with his house man, Marrakech, 1969

PAGE 26
Christina Onassis, Paris, 1969

PAGE 27
Fashion model, Long Island, NY, 1940s

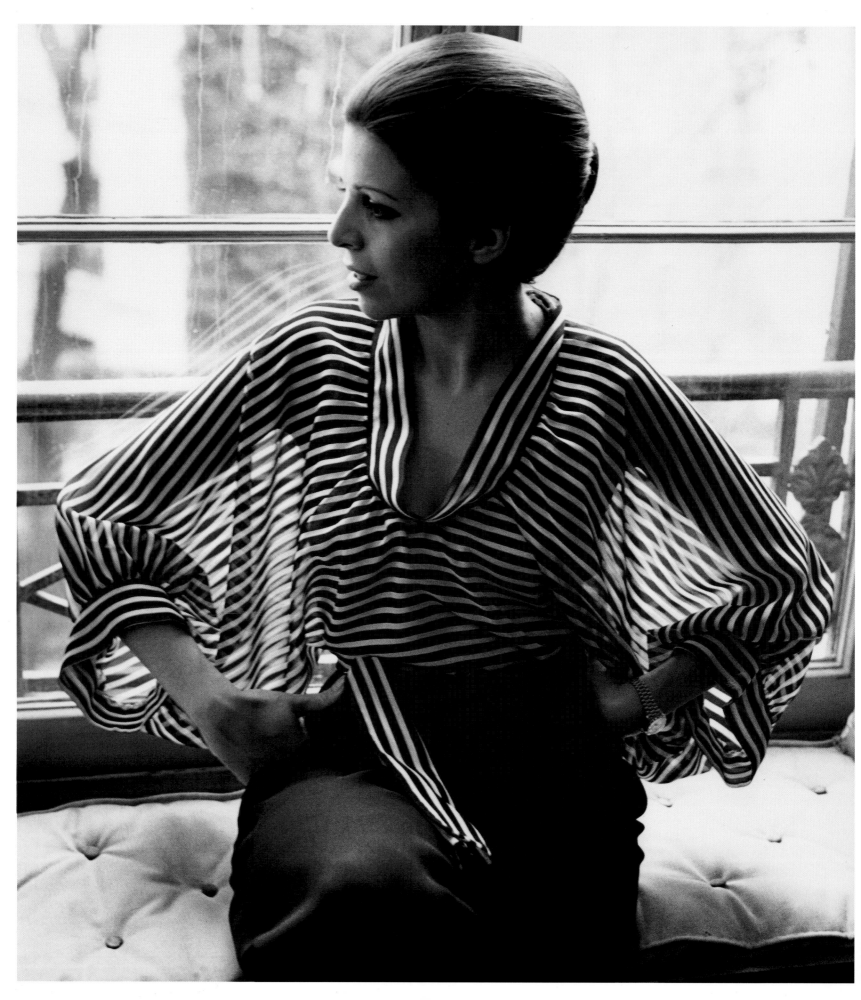

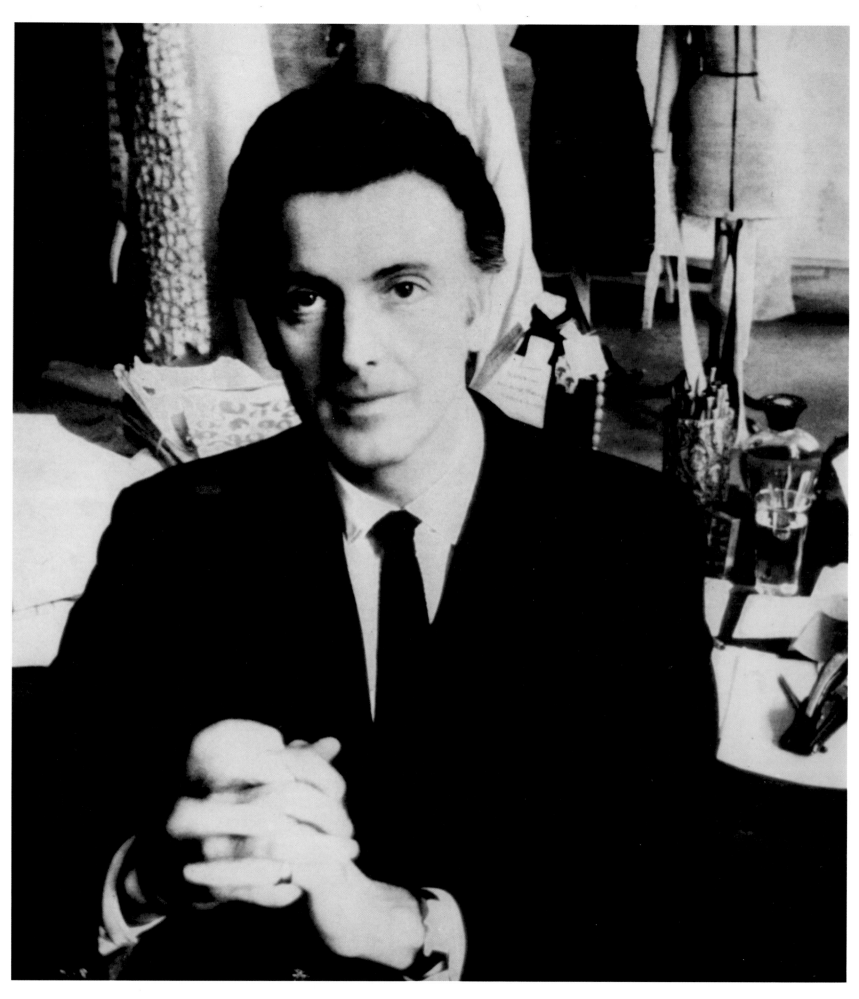

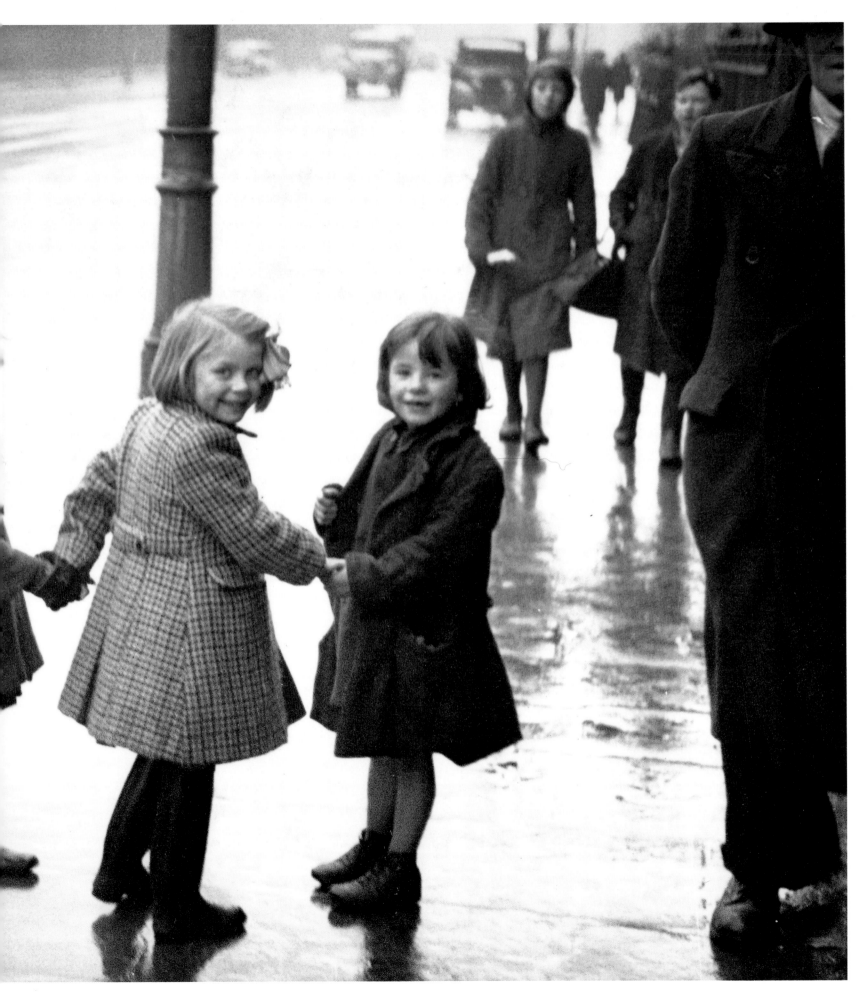

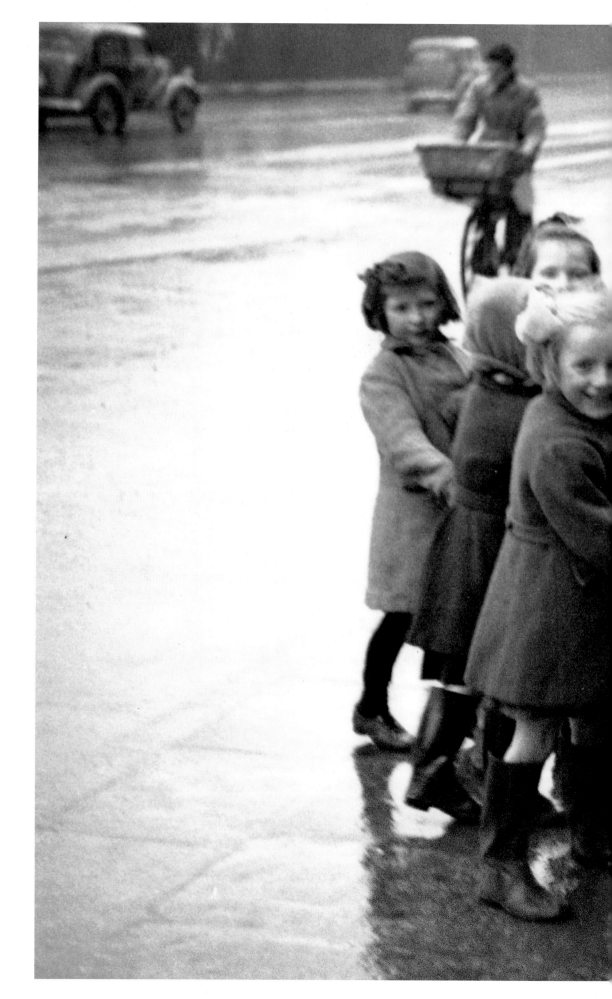

OPPOSITE
Girls playing ring-around-the-rosy,
Dublin, 1948

PAGE 30
Couturier Hubert de Givenchy
in his atelier, Paris, 1968

PAGE 31
Model, Paris, 1947

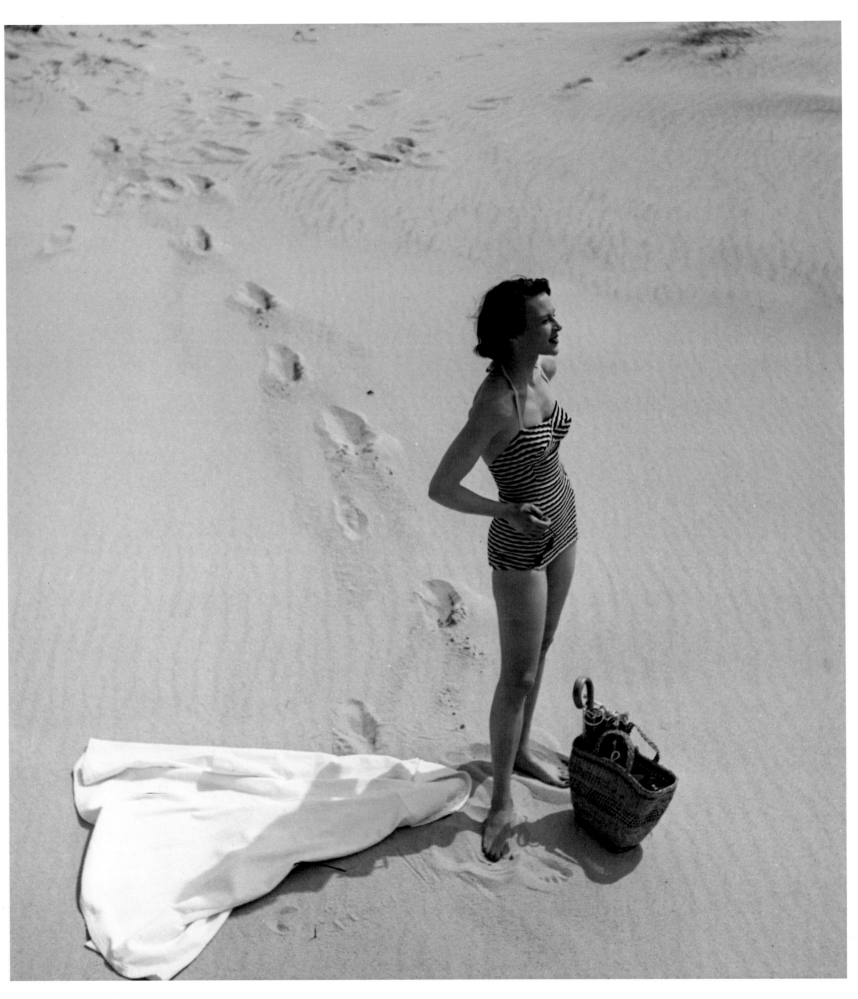

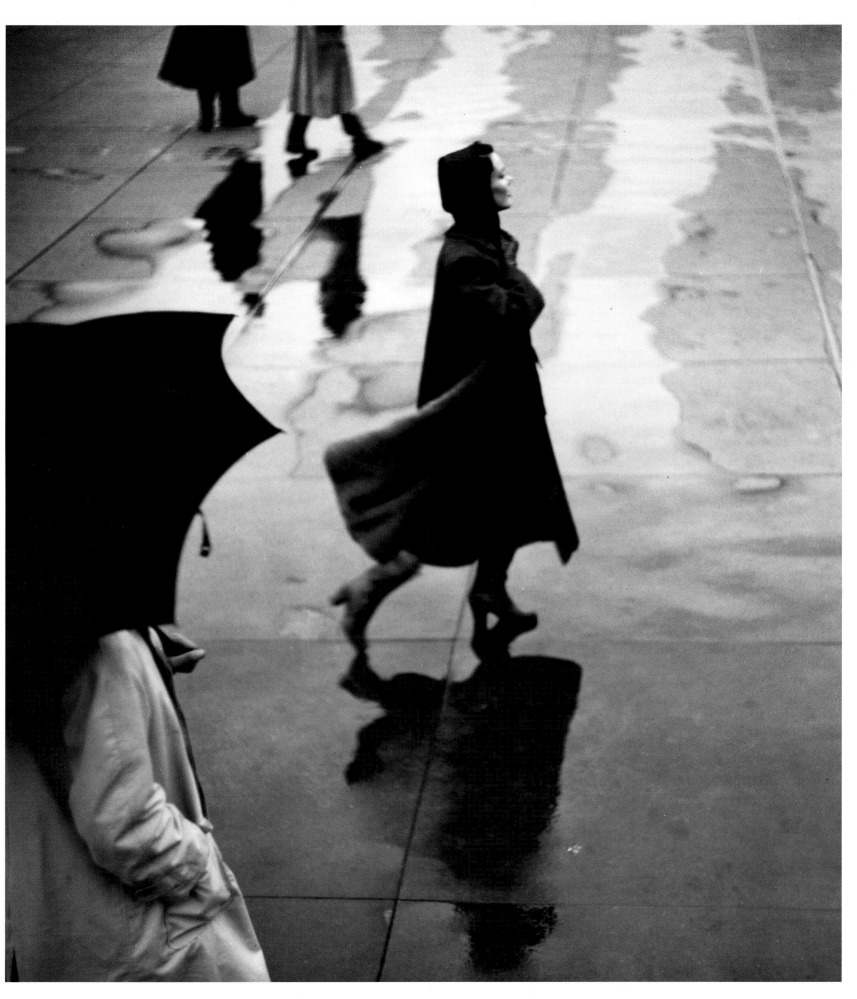

OPPOSITE
Children on Gaspé Peninsula, Quebec, Canada, 1944

PAGE 34
Hanging out in Dublin, 1948

PAGE 35
Writer Seán Ó Faoláin, Ireland, 1948

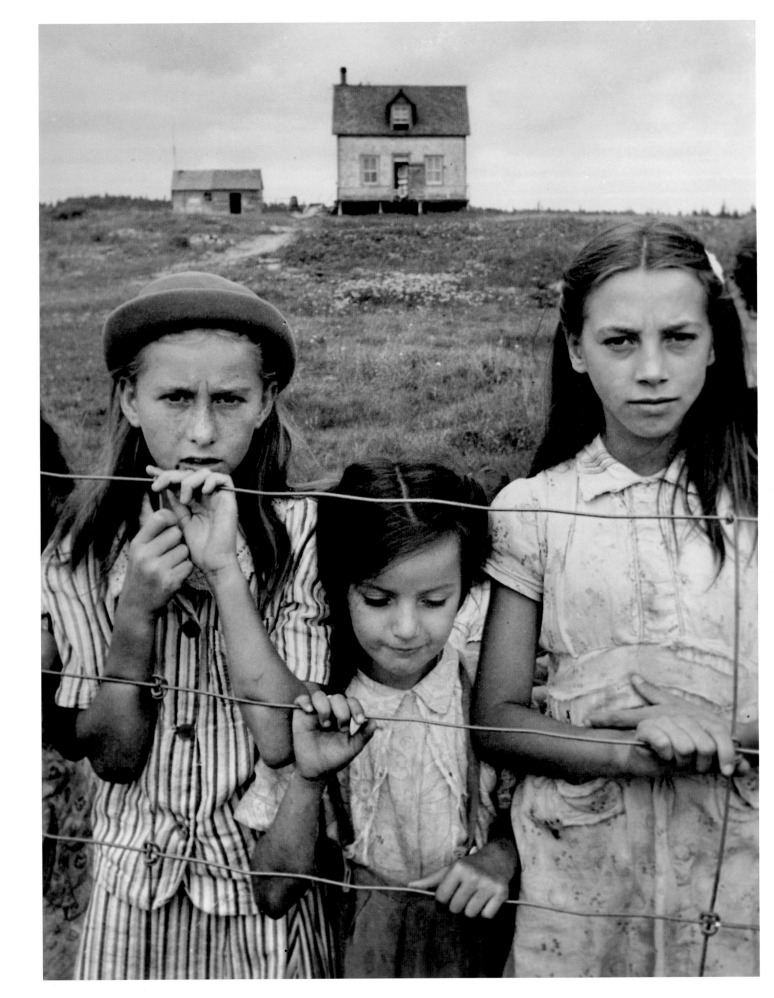

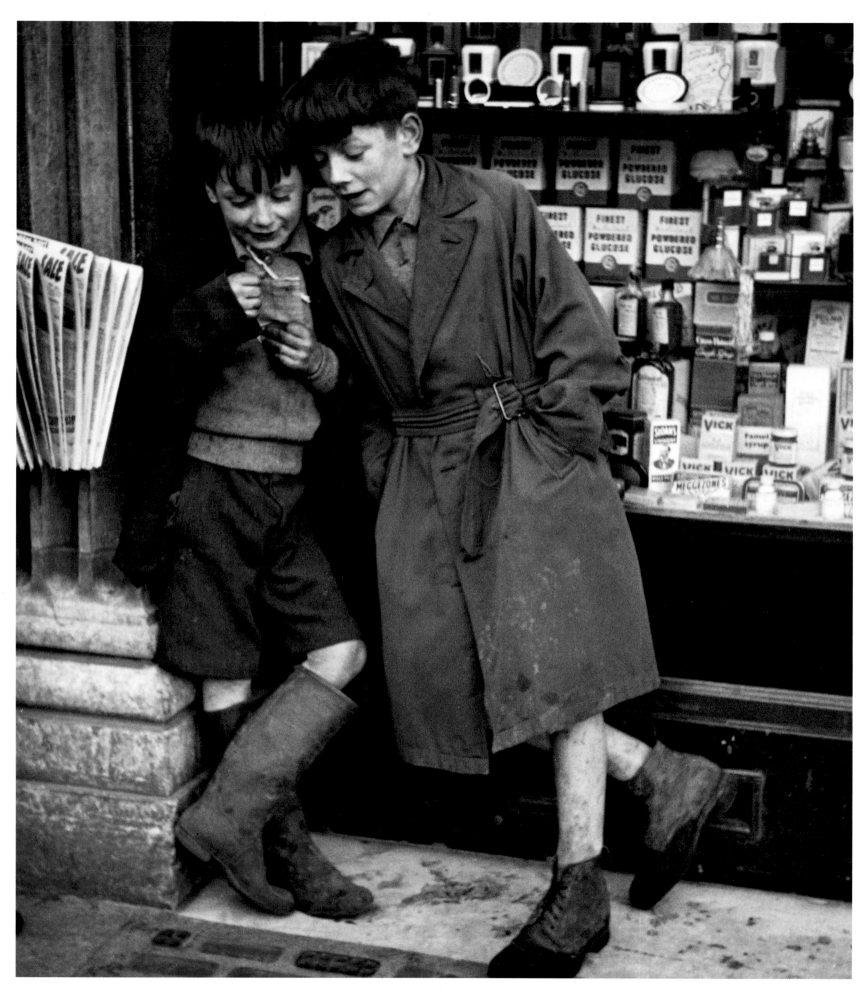

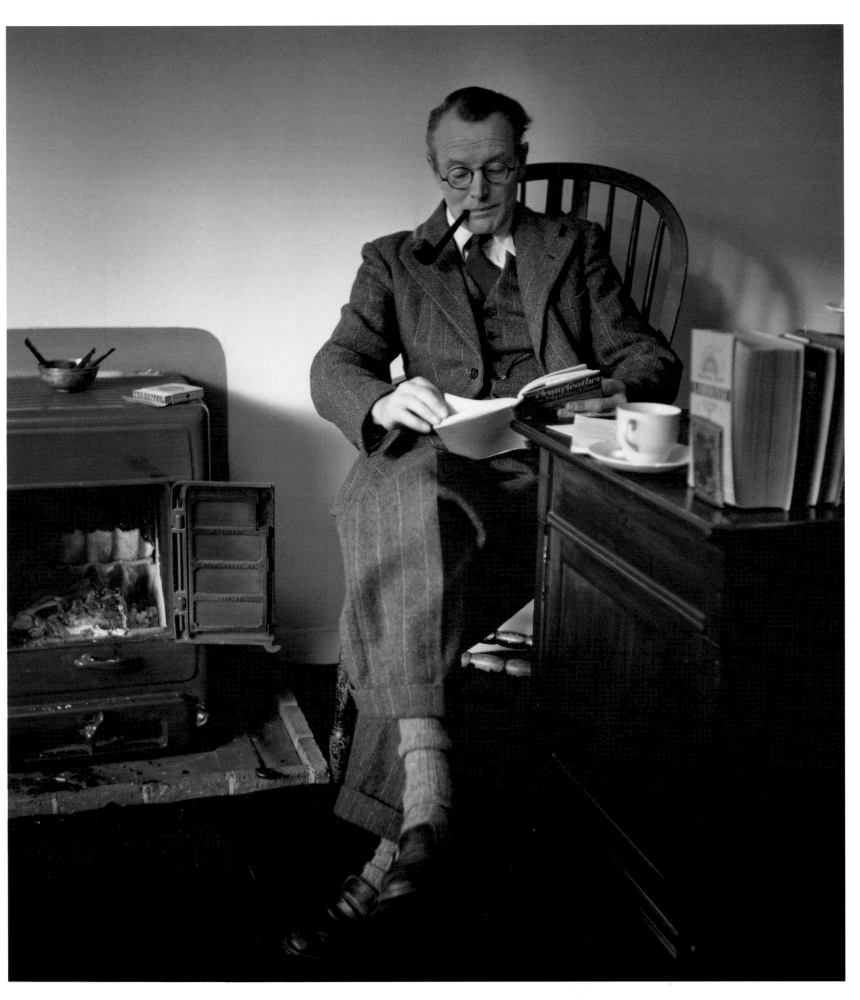

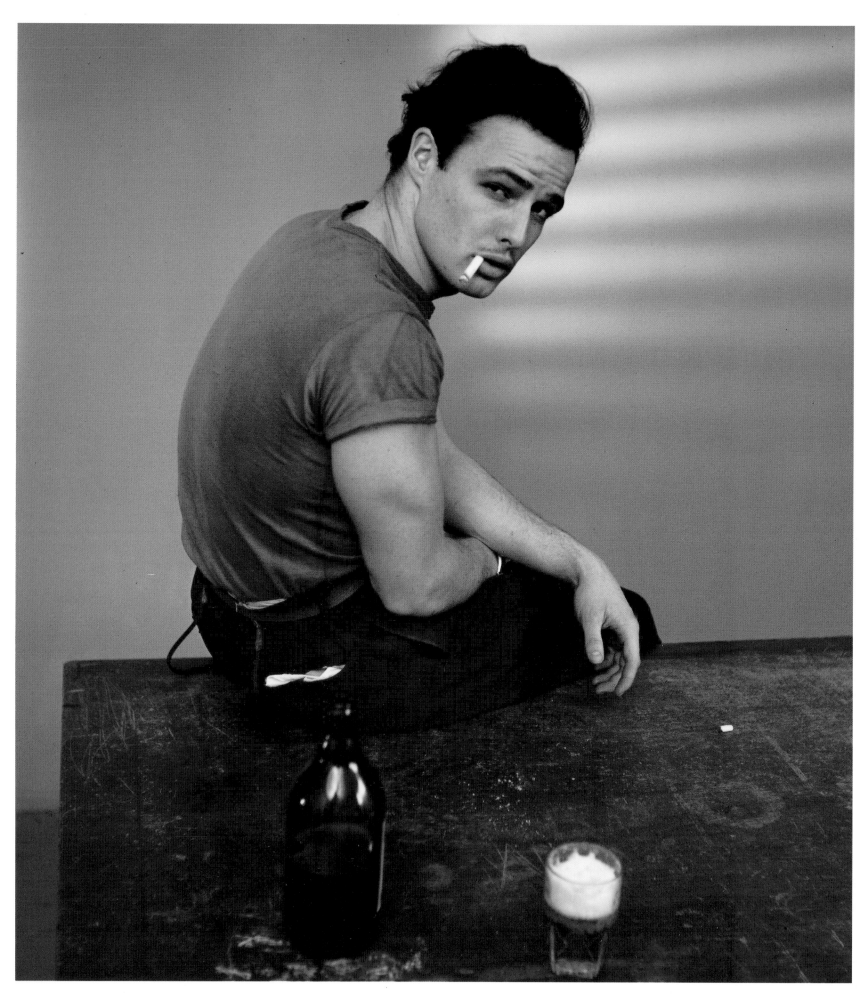

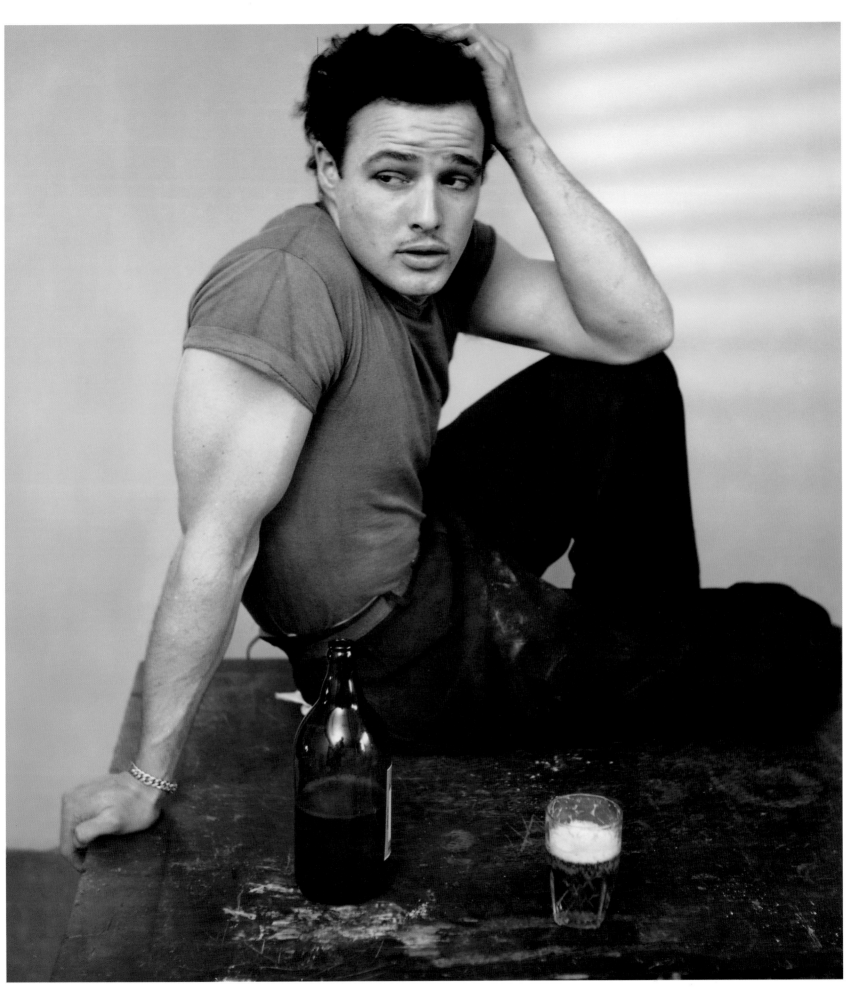

PAGES 36–37
Actor Marlon Brando, while appearing in New York in Tennessee Williams's
A Streetcar Named Desire, 1948

OPPOSITE
Modern dancer and choreographer Valerie Bettis, New York, 1947

PAGE 40
Jennifer-Mary Crimmins beneath the funnel of the SS *United States,* New York, 1952

PAGE 41
Composer Hoagy Carmichael, New York, 1947

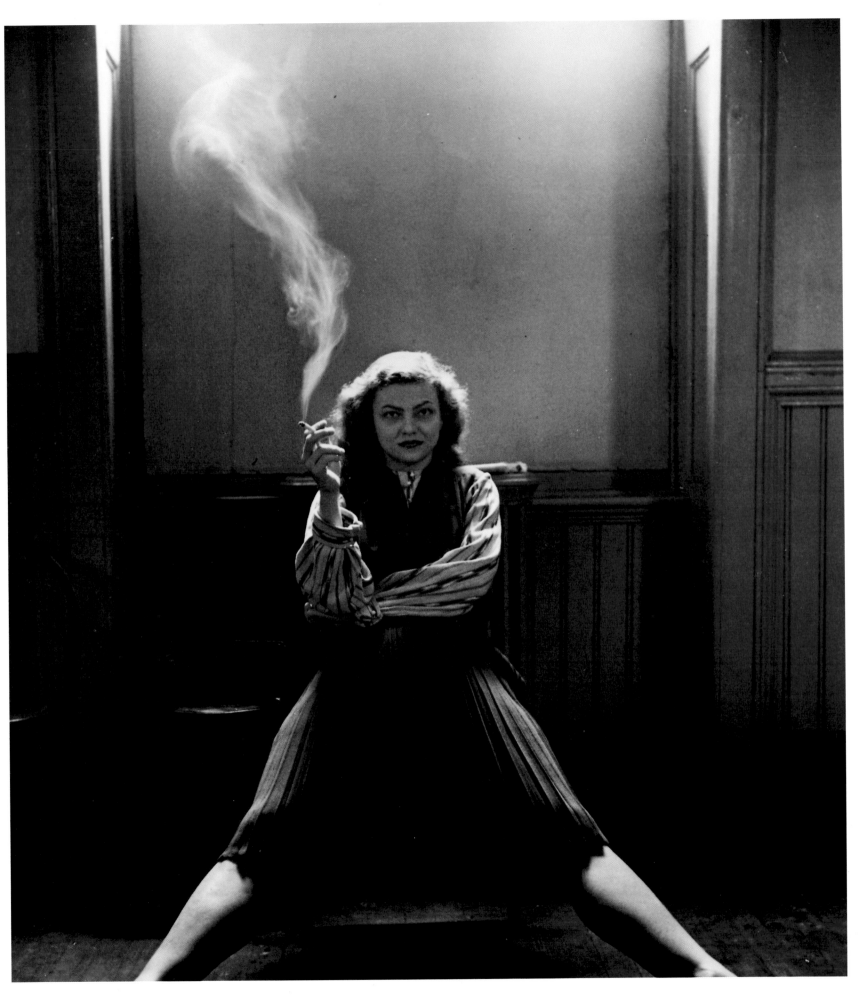

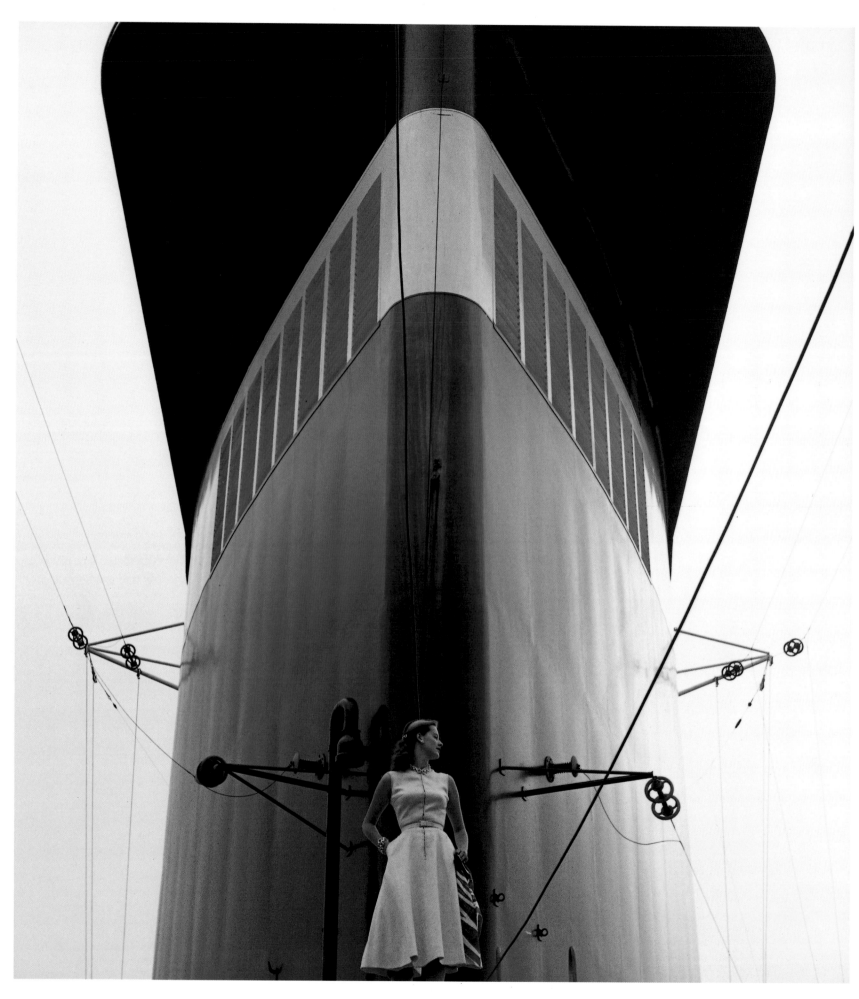

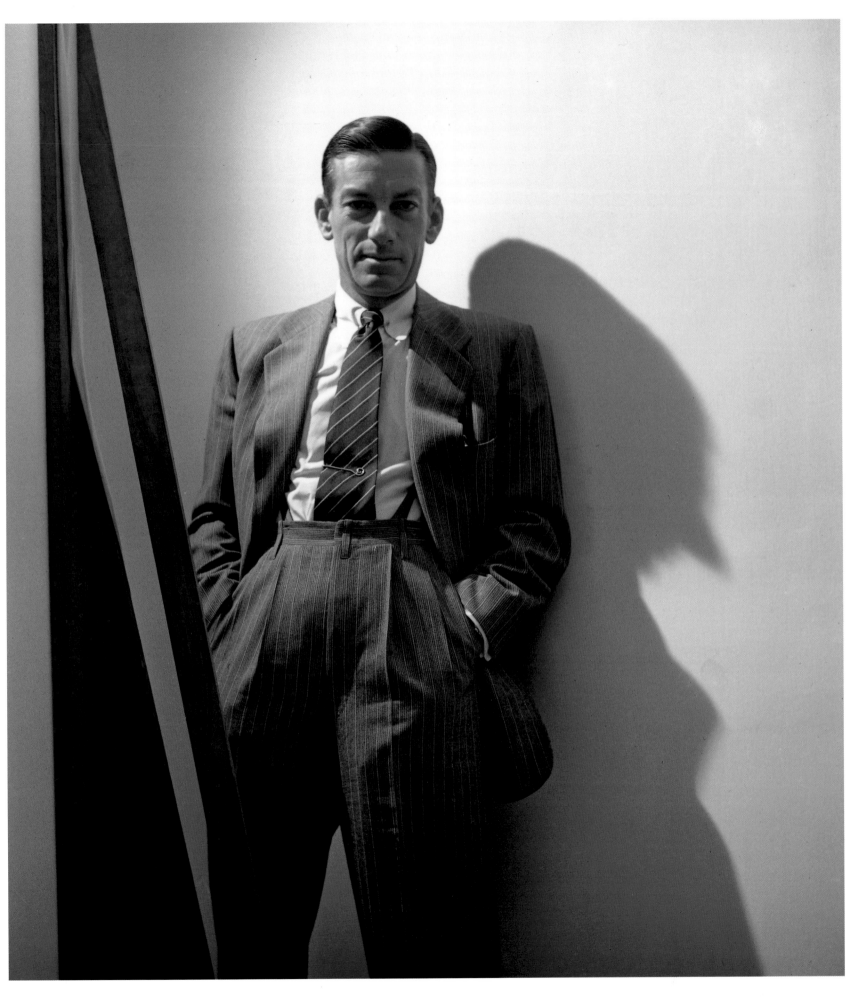

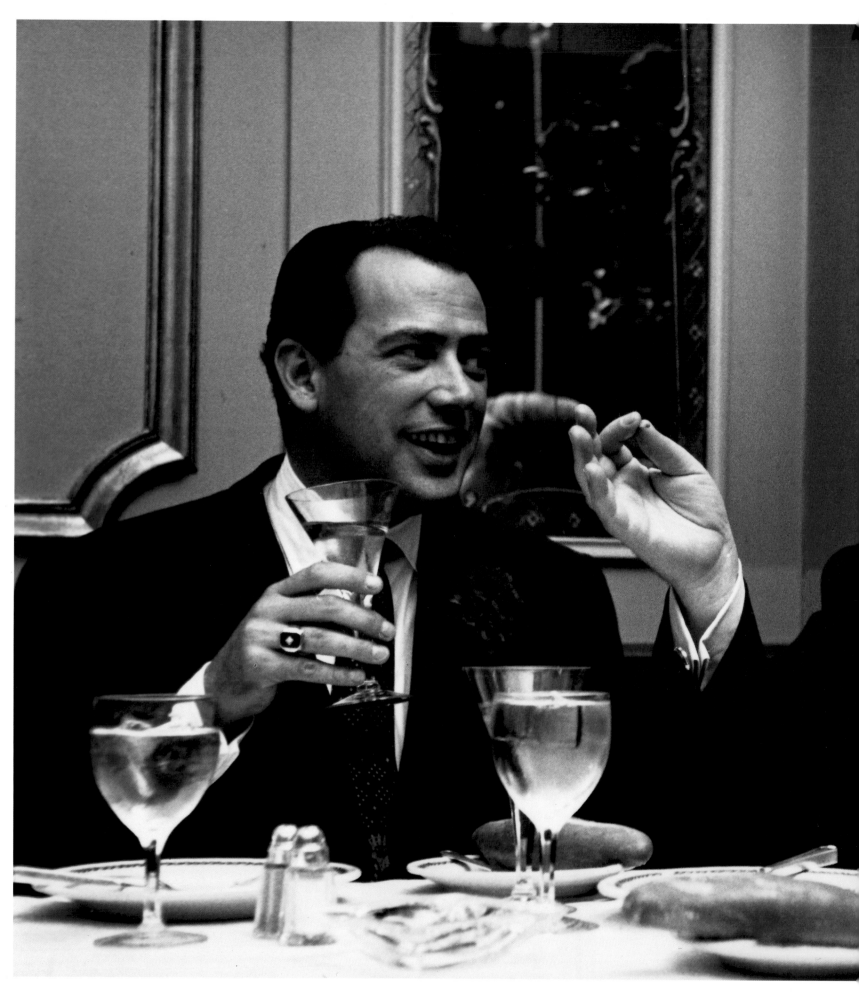

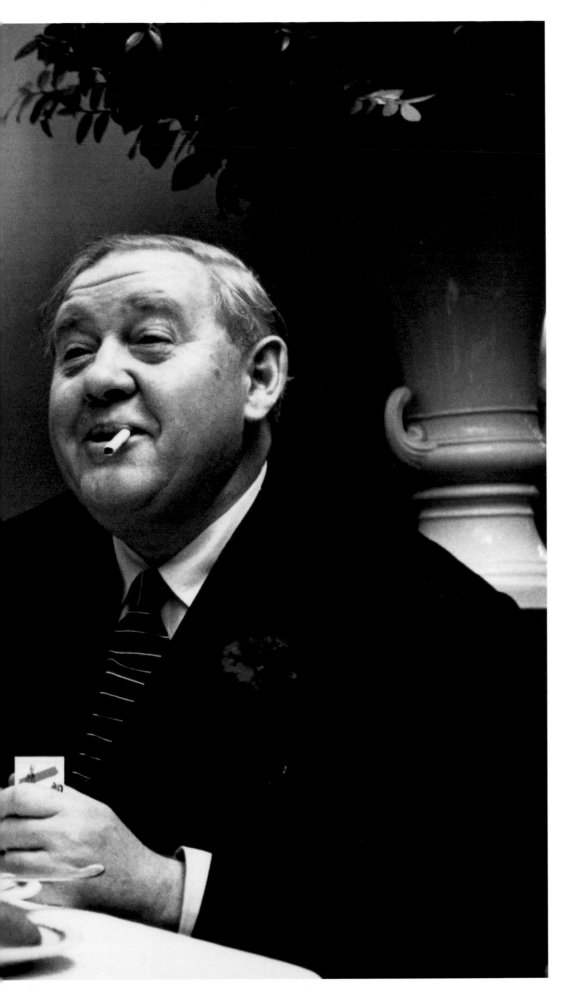

OPPOSITE
Actor Charles Laughton, right, with
friend and producer Paul Gregory, in a
restaurant, New York, 1950s

PAGE 44
Artist Salvador Dalí at a party,
New York, 1950s

PAGE 45
Blues singer Mildred Bailey,
New York, 1940s

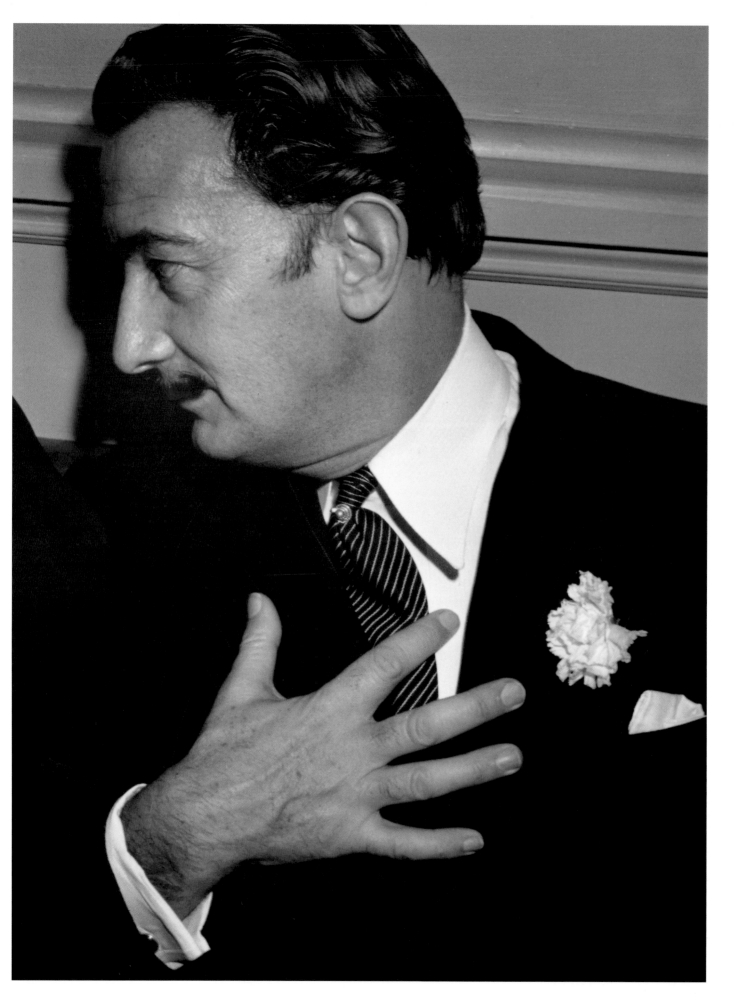

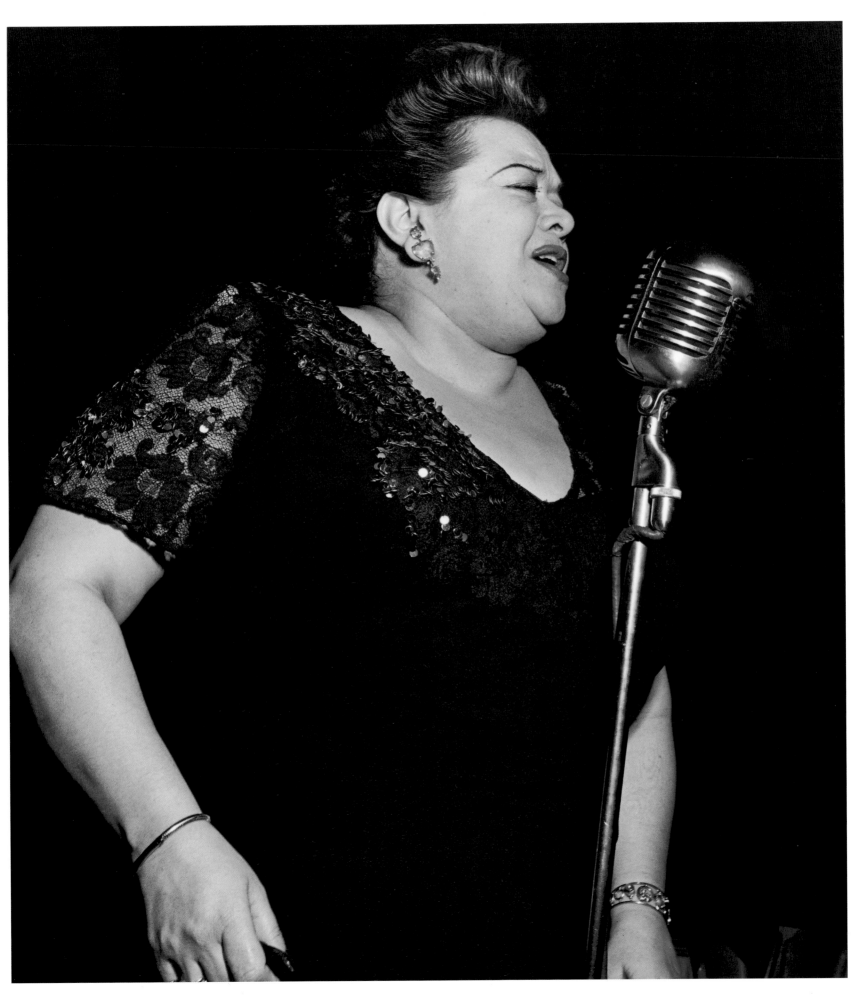

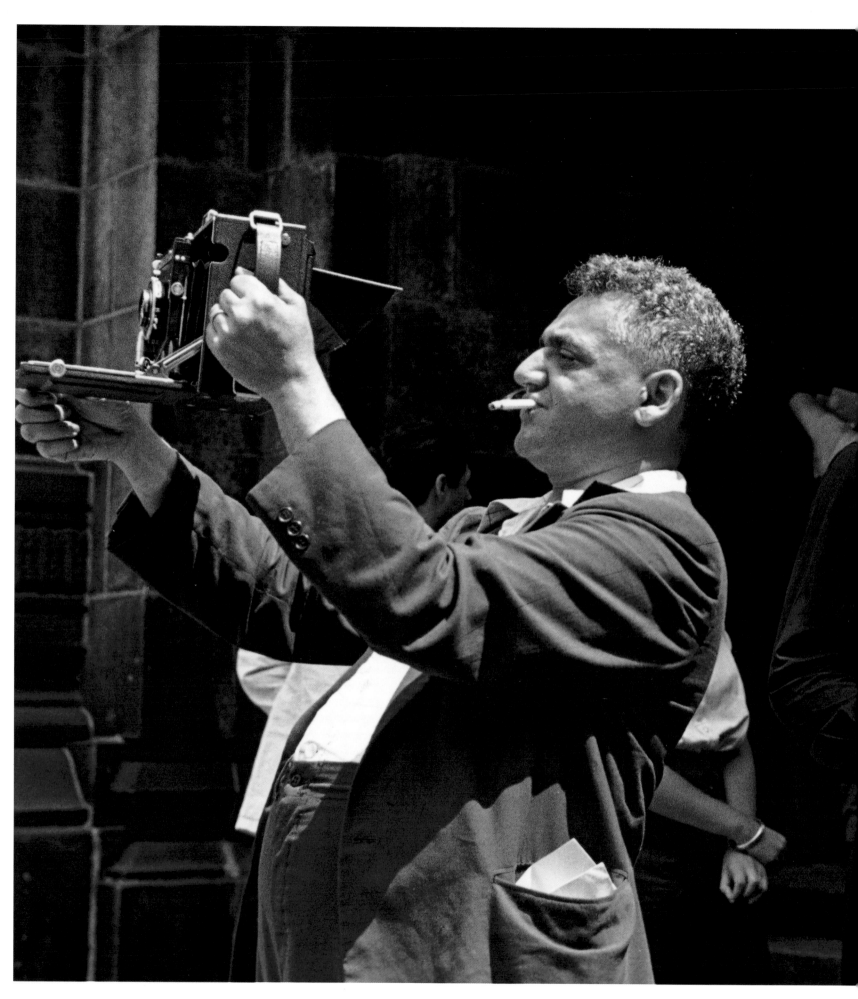

Newspaper photographer Weegee, New York, 1948

Model, 1940s

Jazz composer and conductor, Duke Ellington, Toronto, 1940s

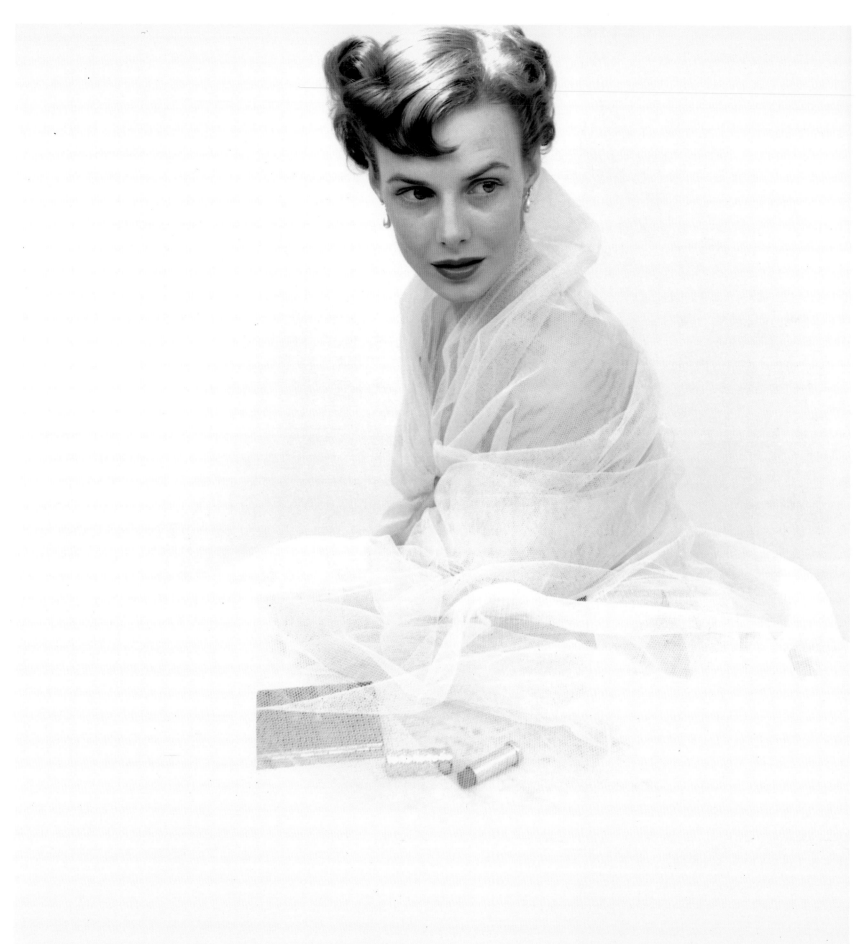

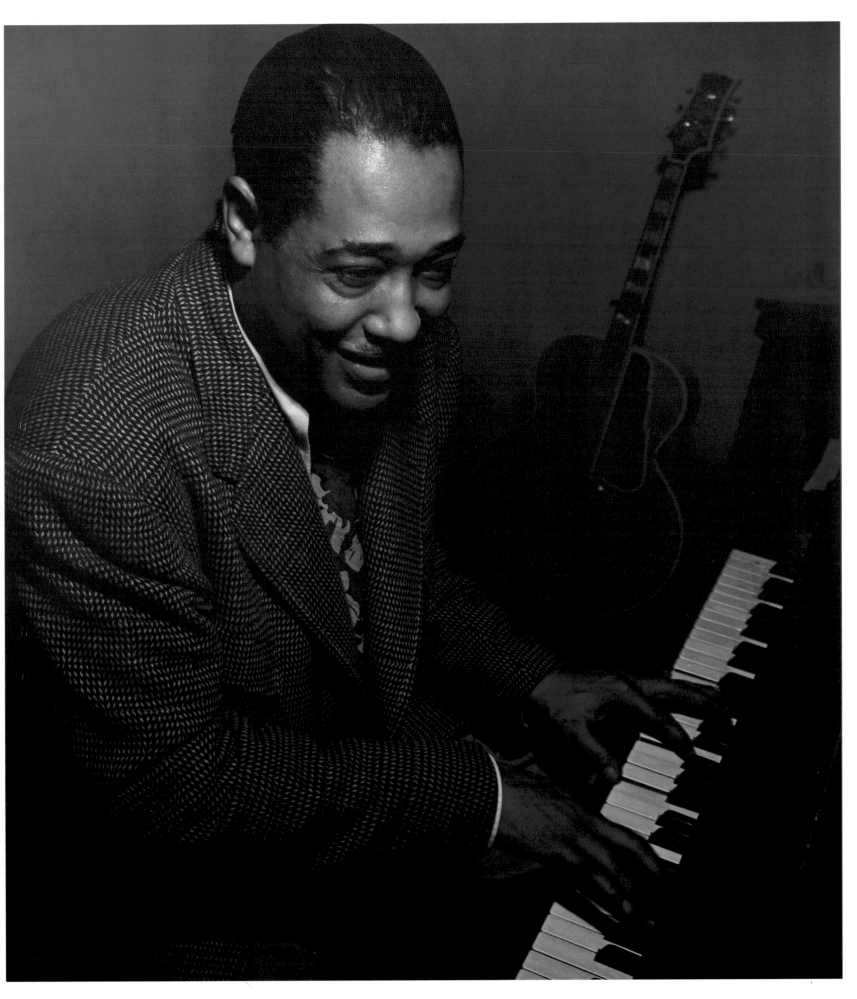

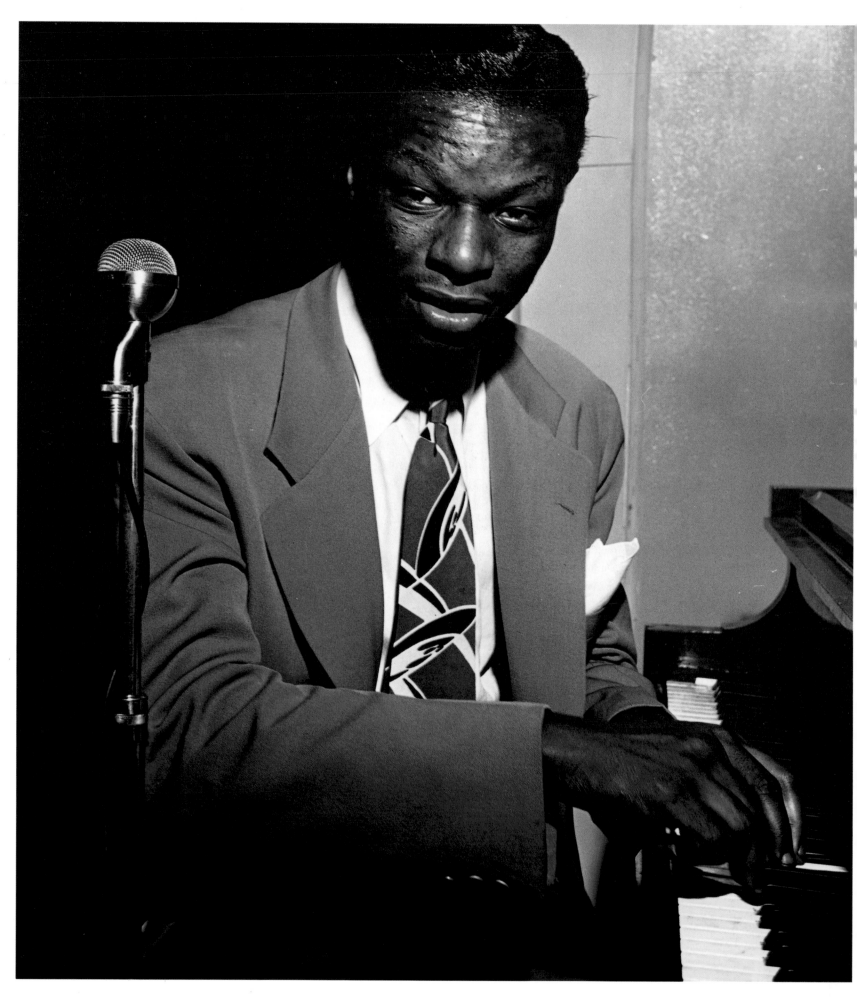

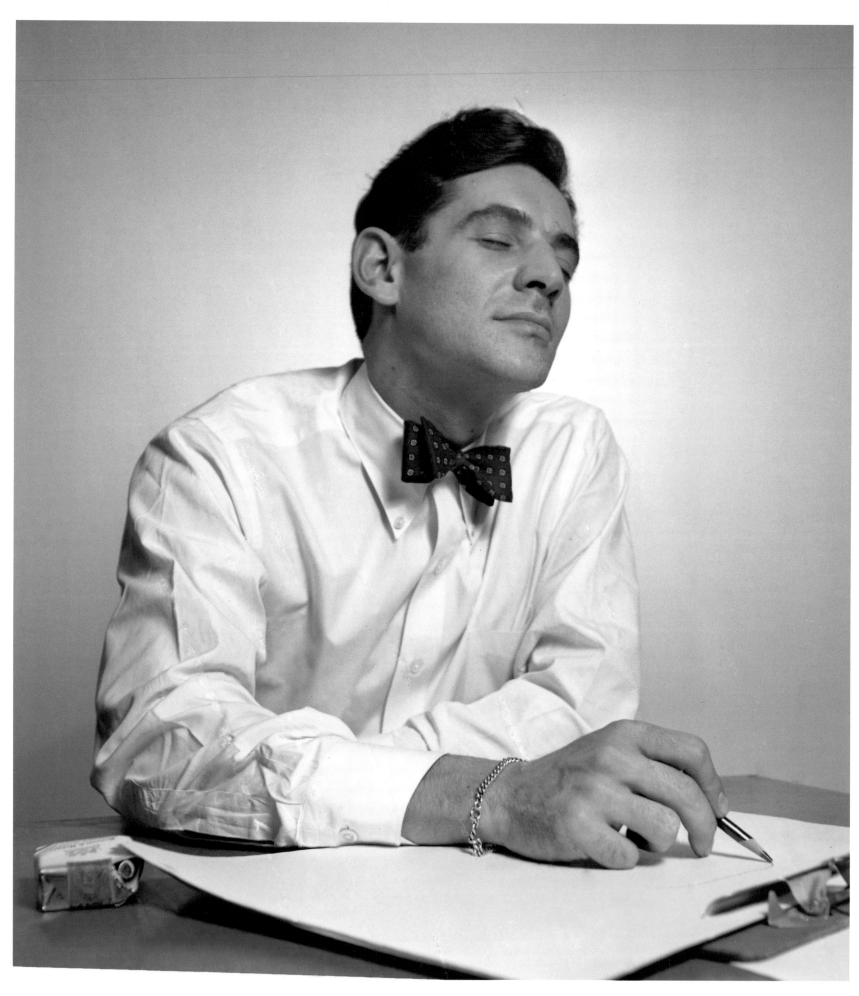

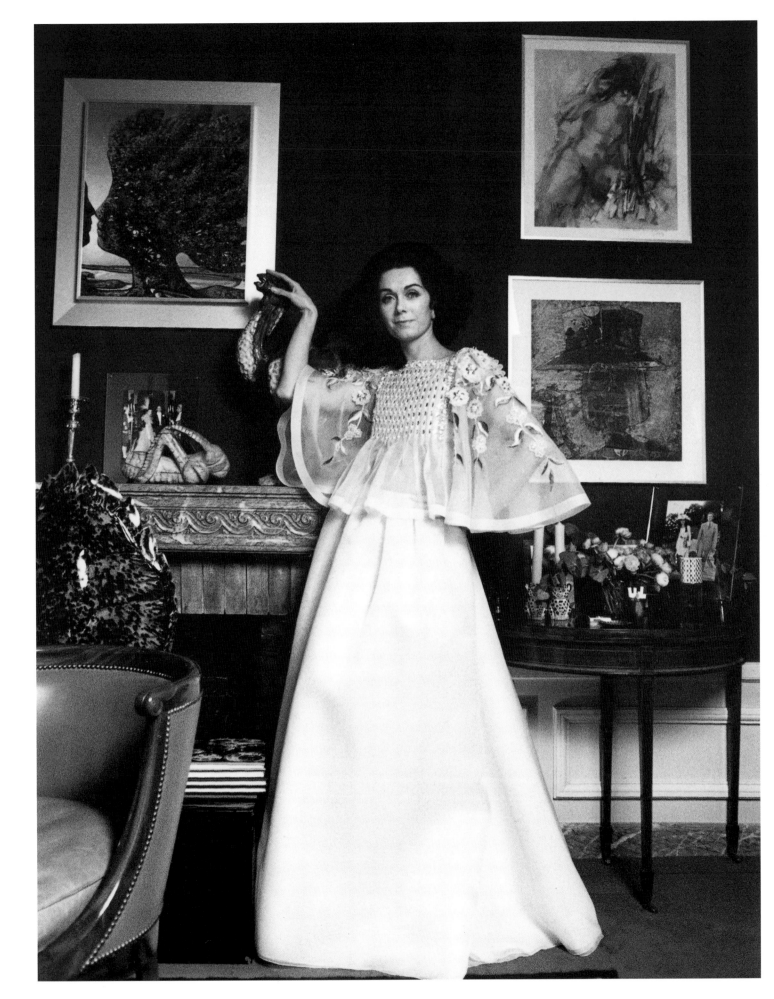

Couturier Pierre Cardin, Paris, 1967

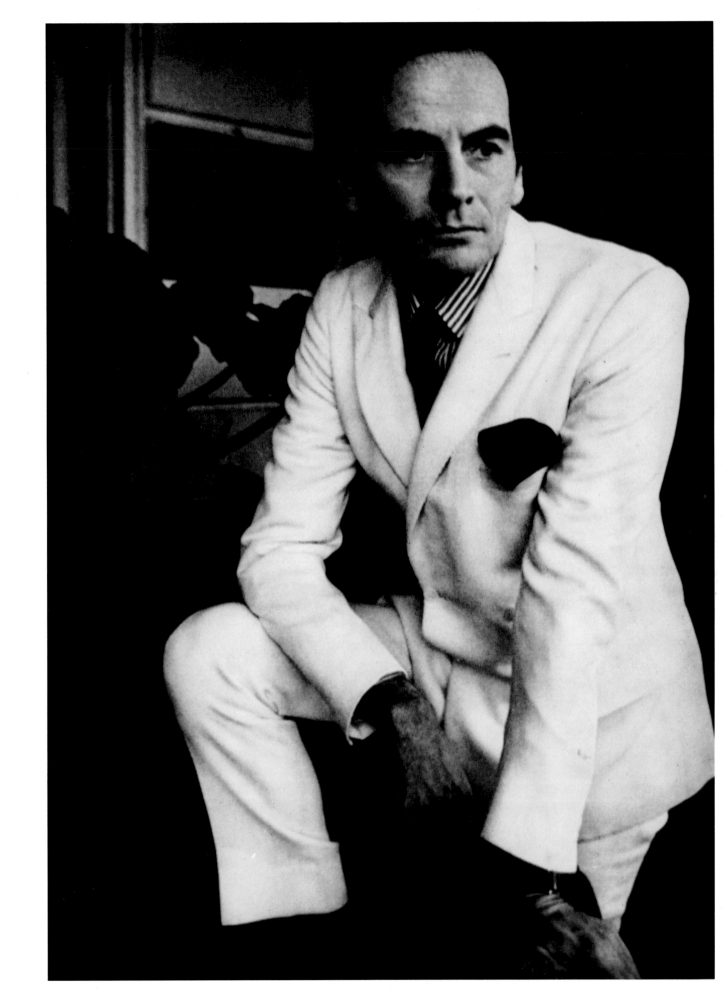

OPPOSITE
Jazz pianist James P. Johnson, New York, 1940s

PAGE 58
Isabel Goldsmith, New York, 1970s

PAGE 59
Model in leopard coat, New York, 1954

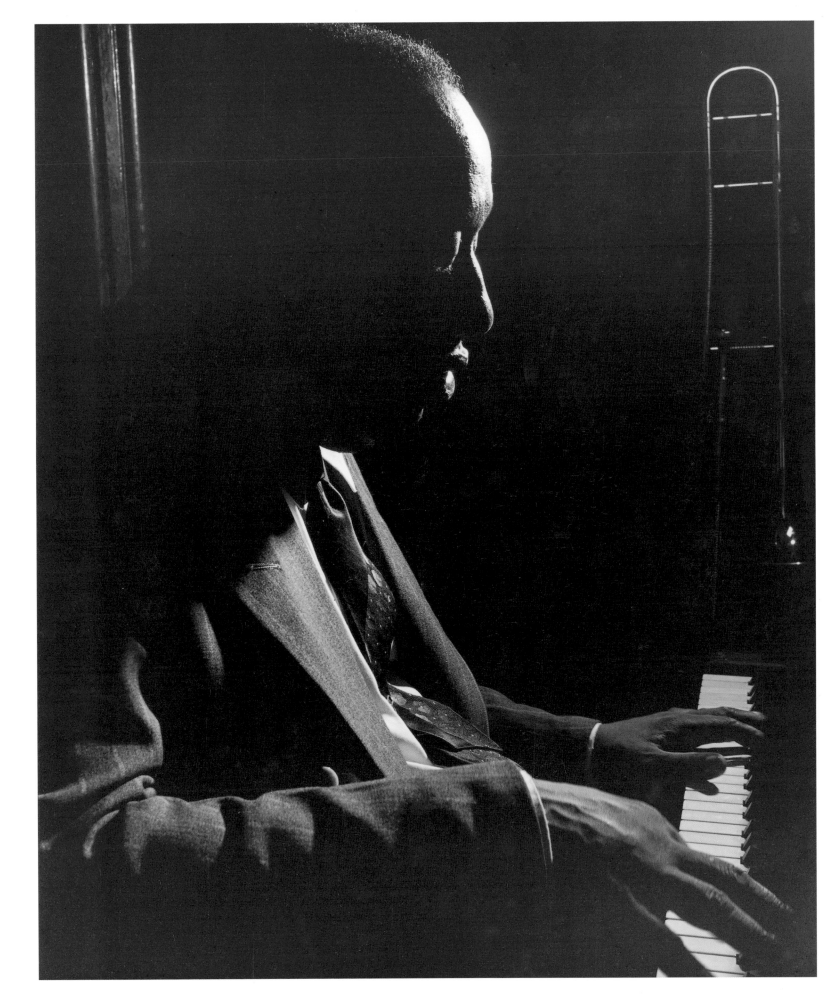

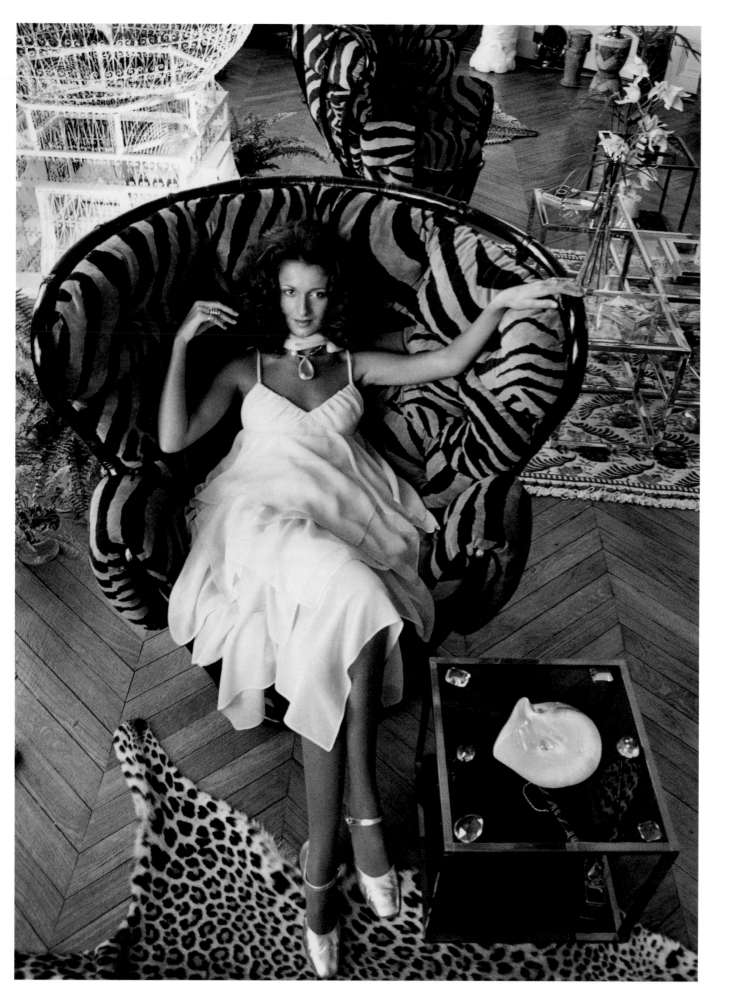

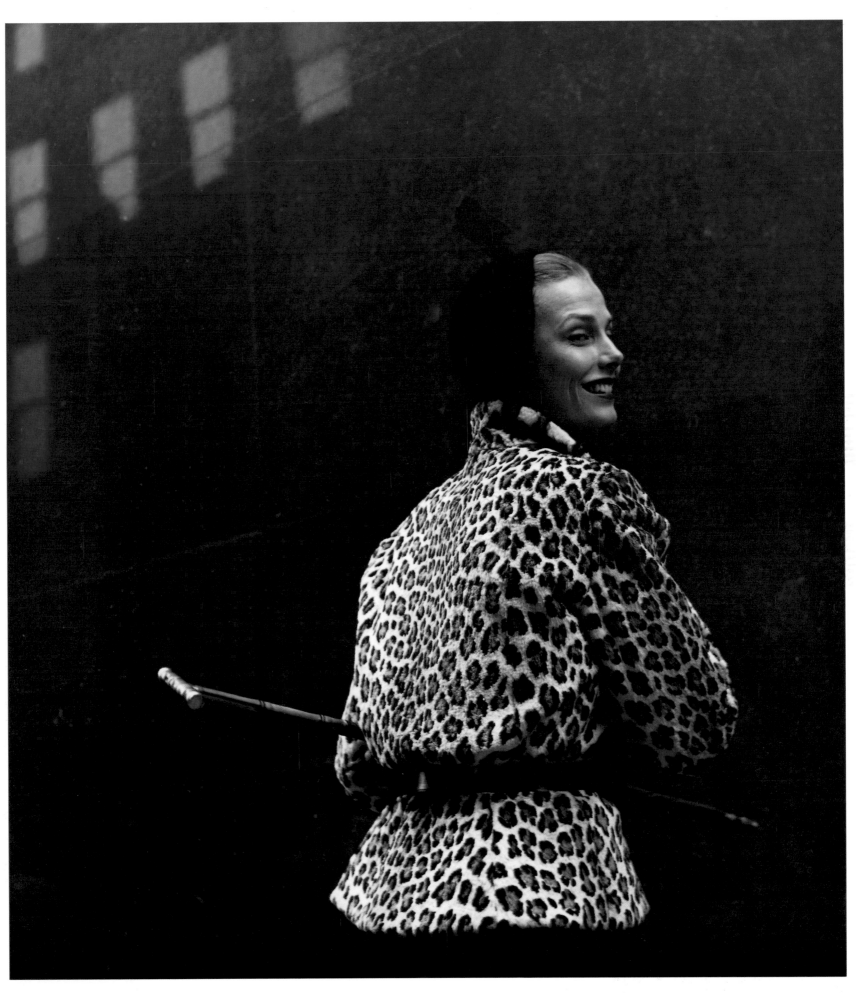

Playwright George S. Kaufman, New York, 1950s

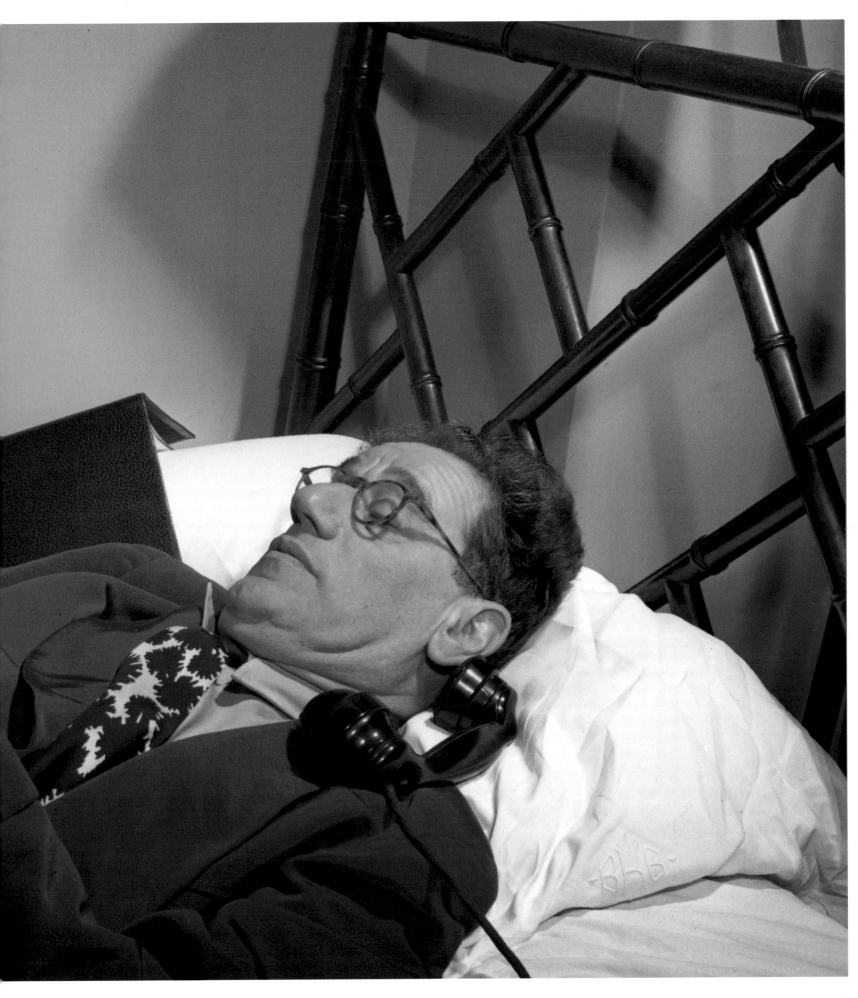

The Duke and Duchess of Windsor, Nassau, Bahamas, 1940s

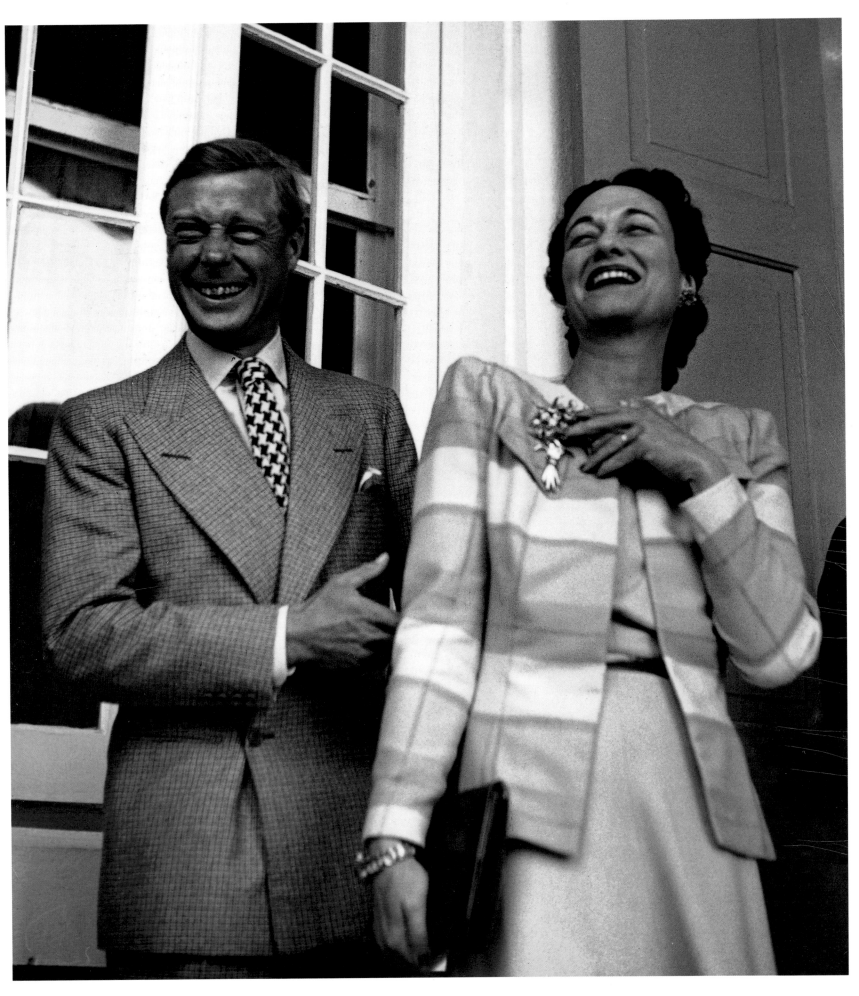

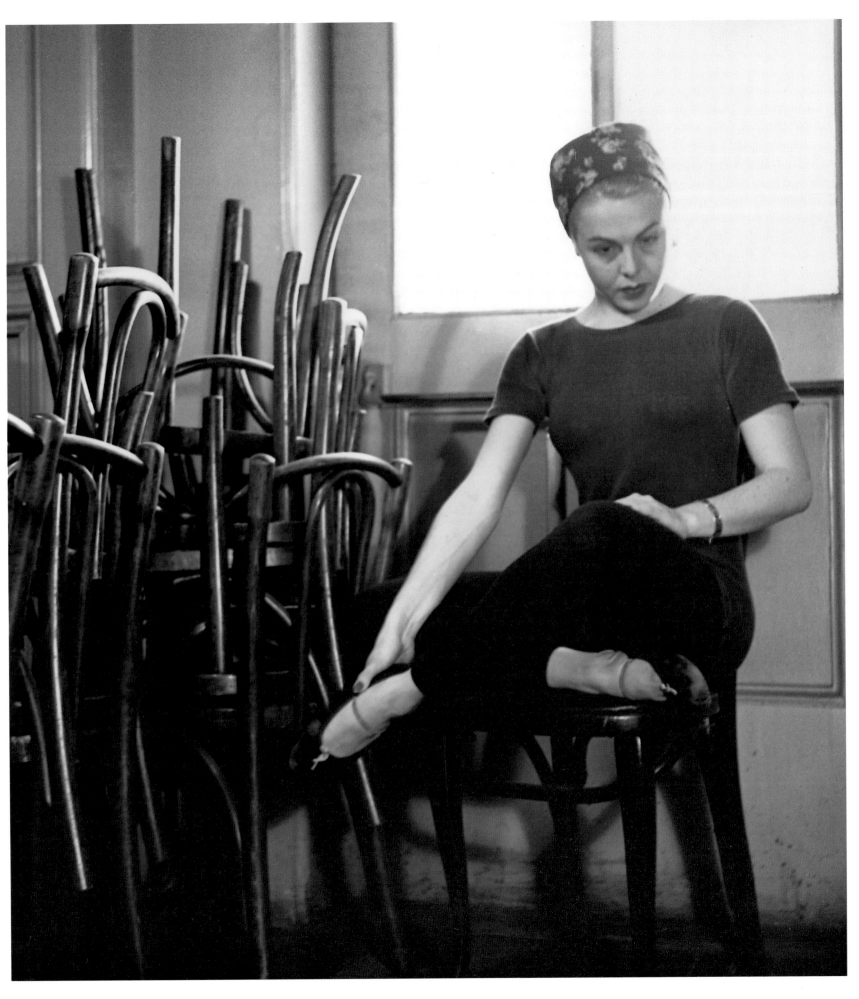

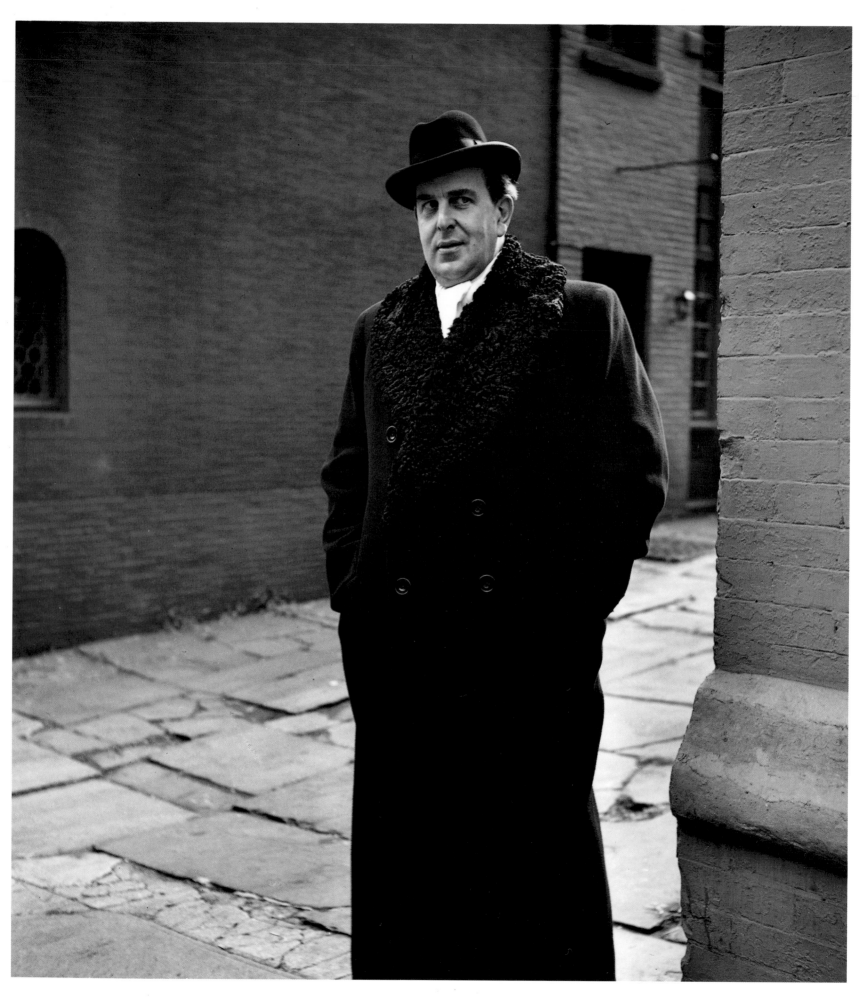

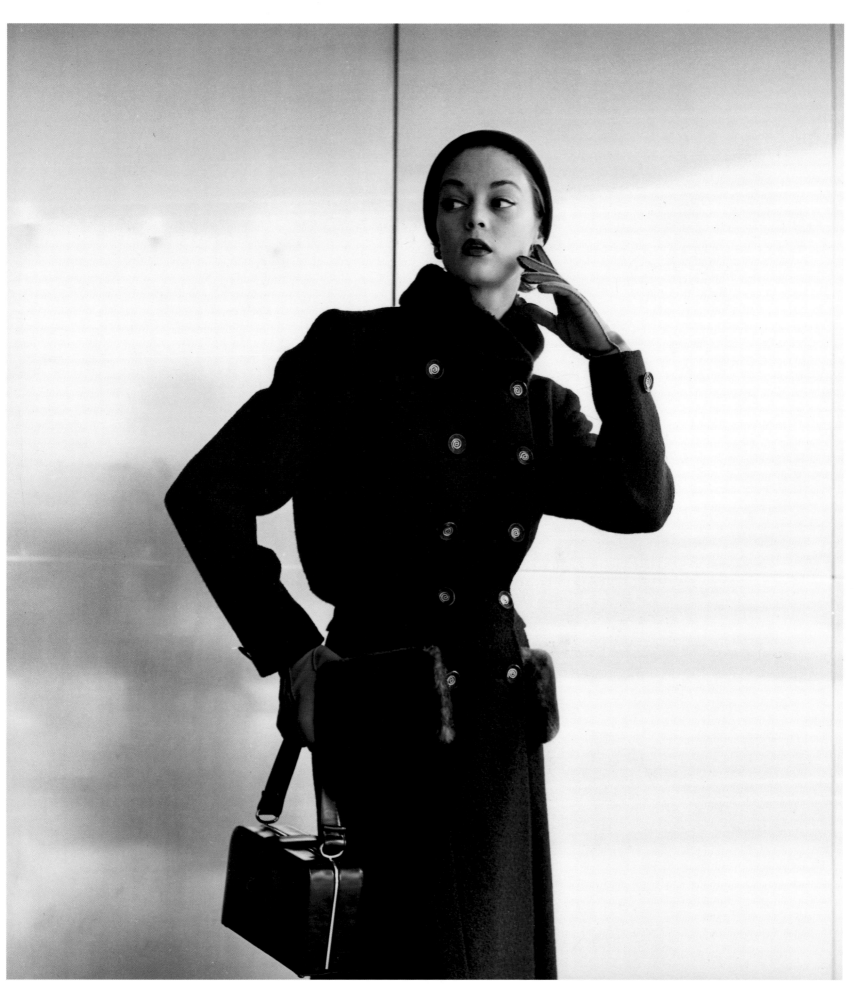

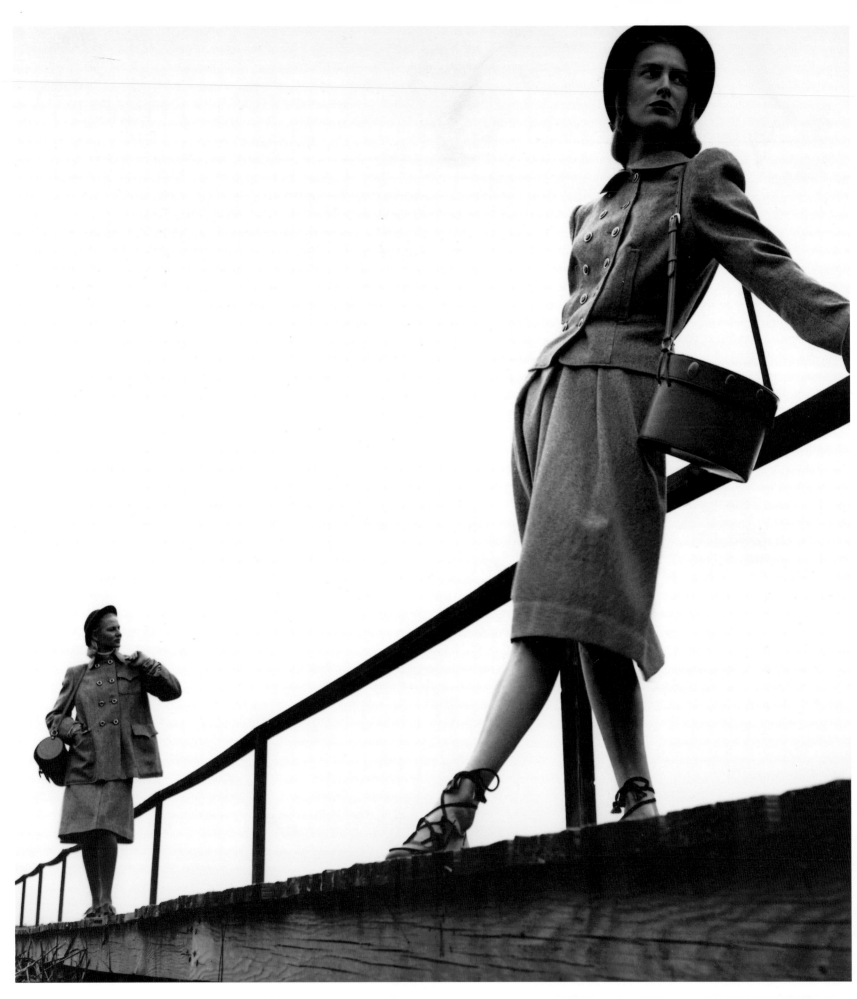

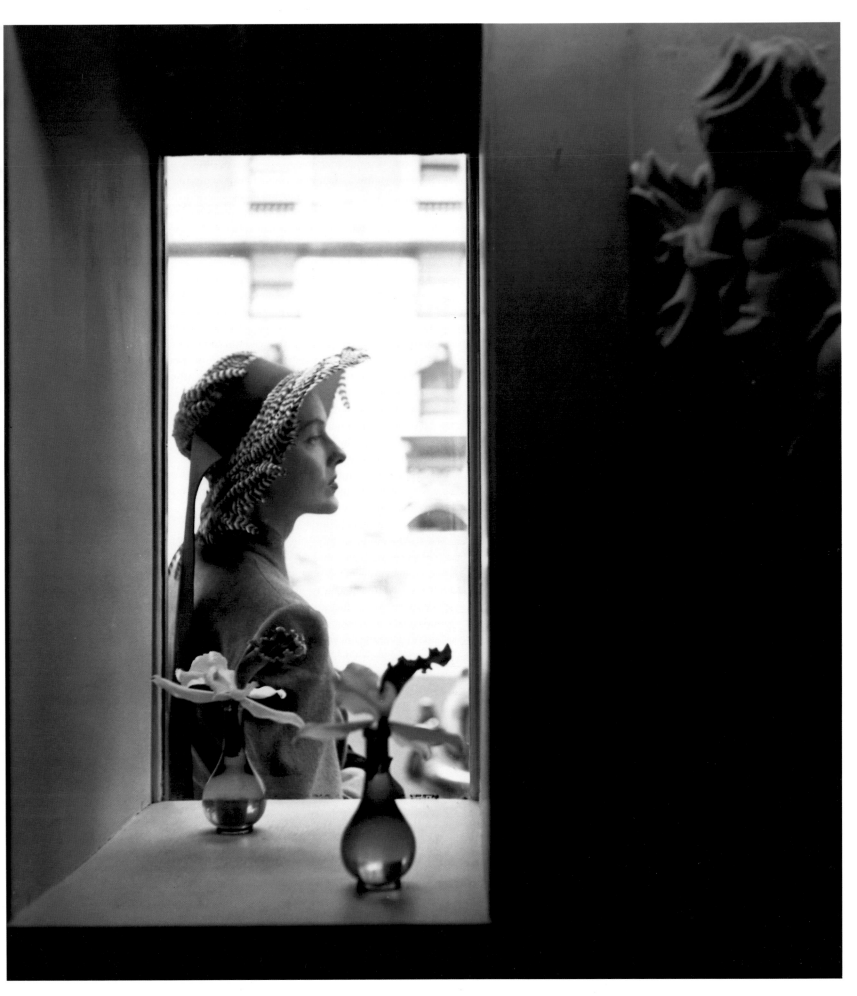

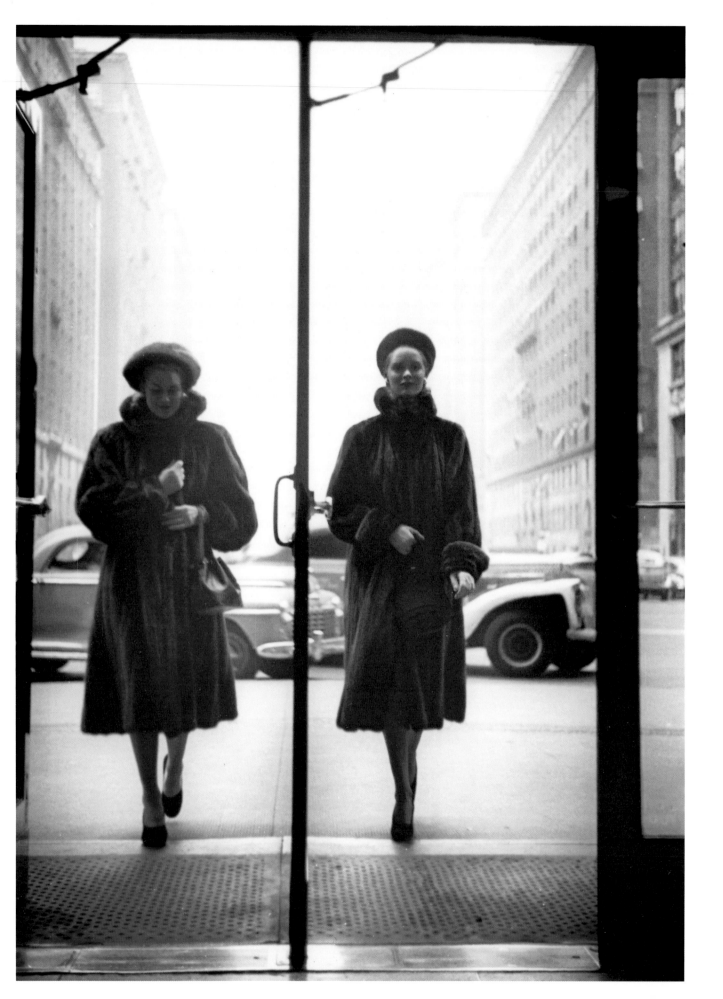

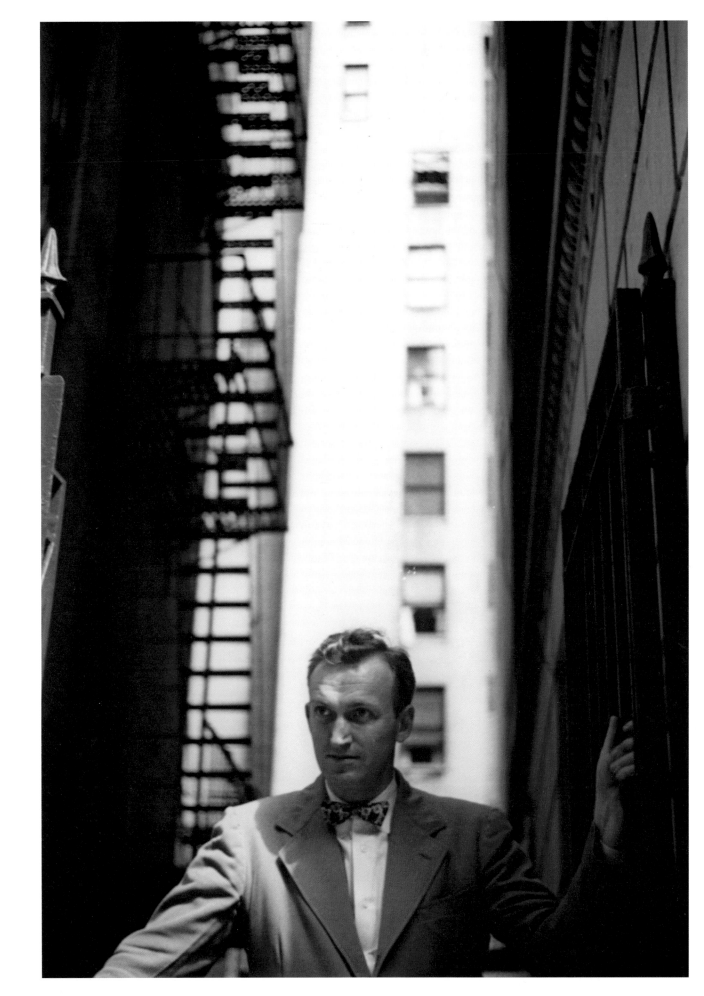

PAGE 70
Models, Park Avenue, New York, 1940s

PAGE 71
Novelist John Horne Burns, New York, 1947

OPPOSITE
Swiss photographer Robert Frank, New York, 1948

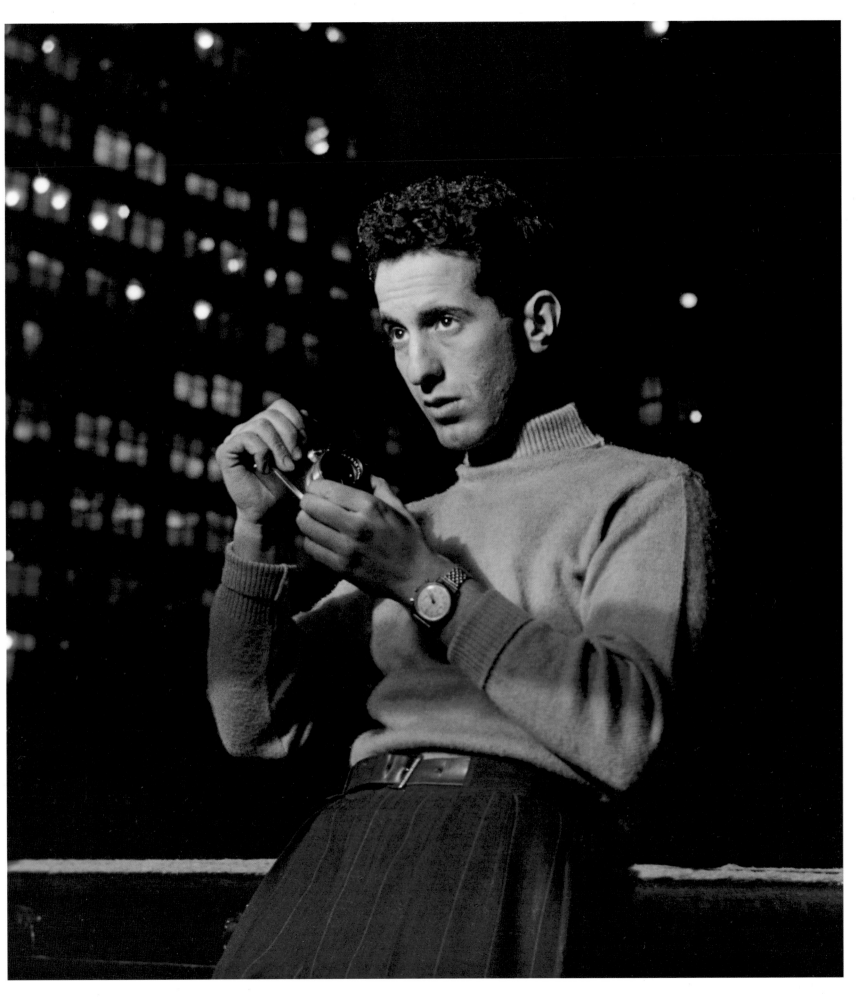

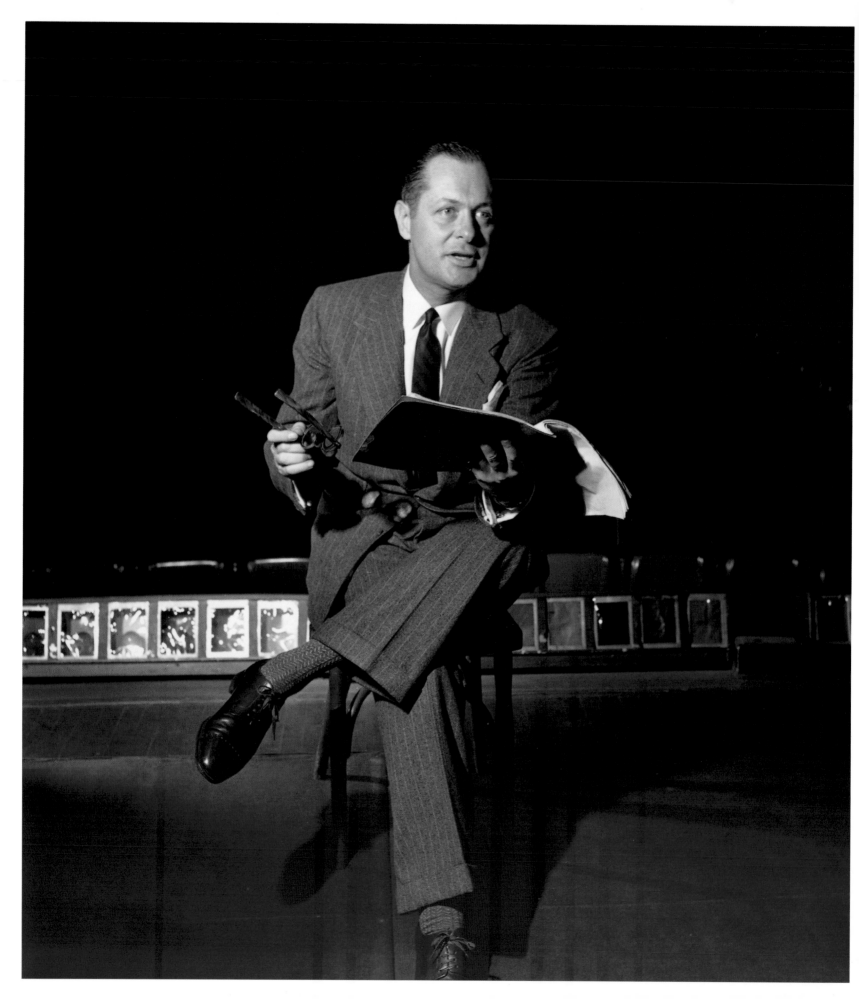

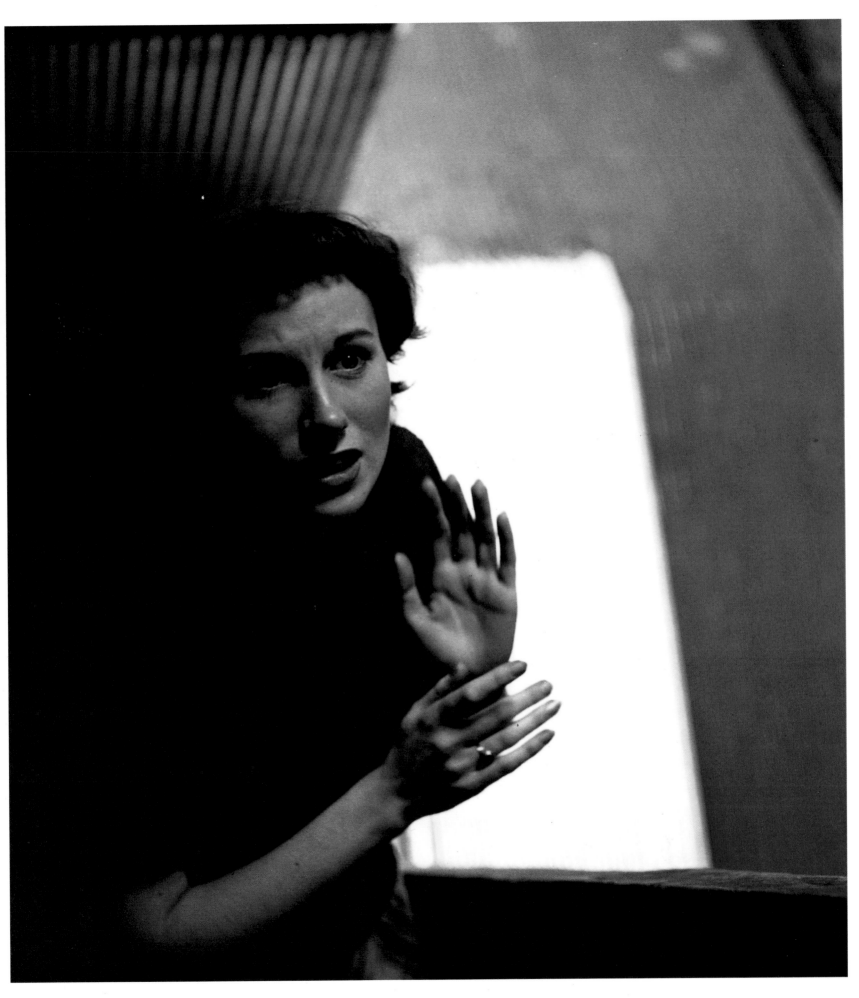

PAGE 74
Actor and director Robert Montgomery during rehearsal, New York, 1950s

PAGE 75
Actress Margaret Phillips in Tennessee Williams's *Summer and Smoke,* New York, 1948

OPPOSITE
Cartoonist Rube Goldberg, New York, 1948

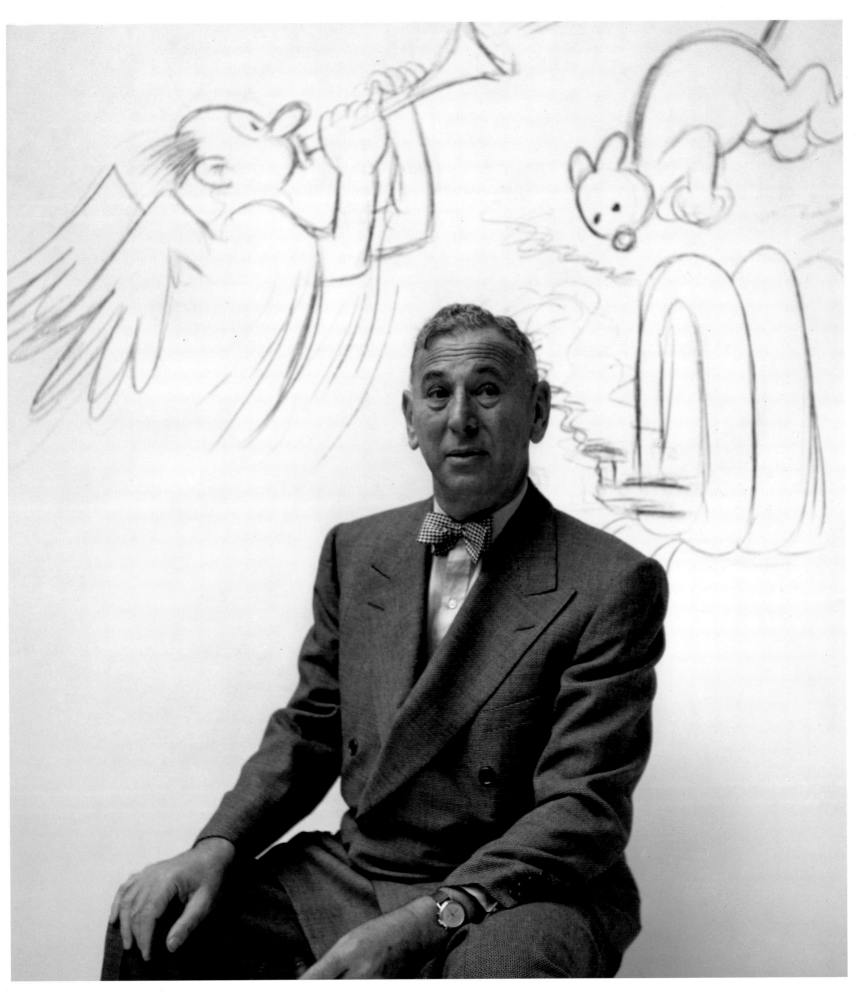

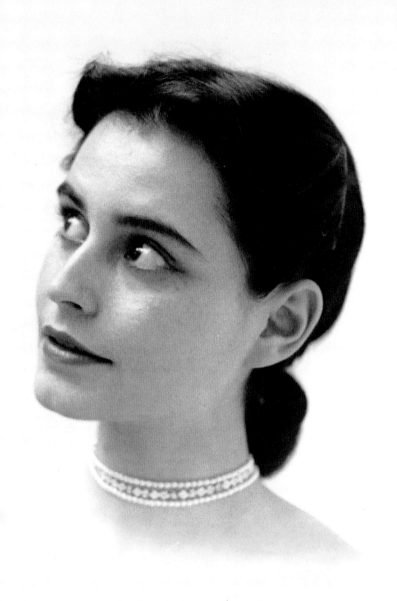

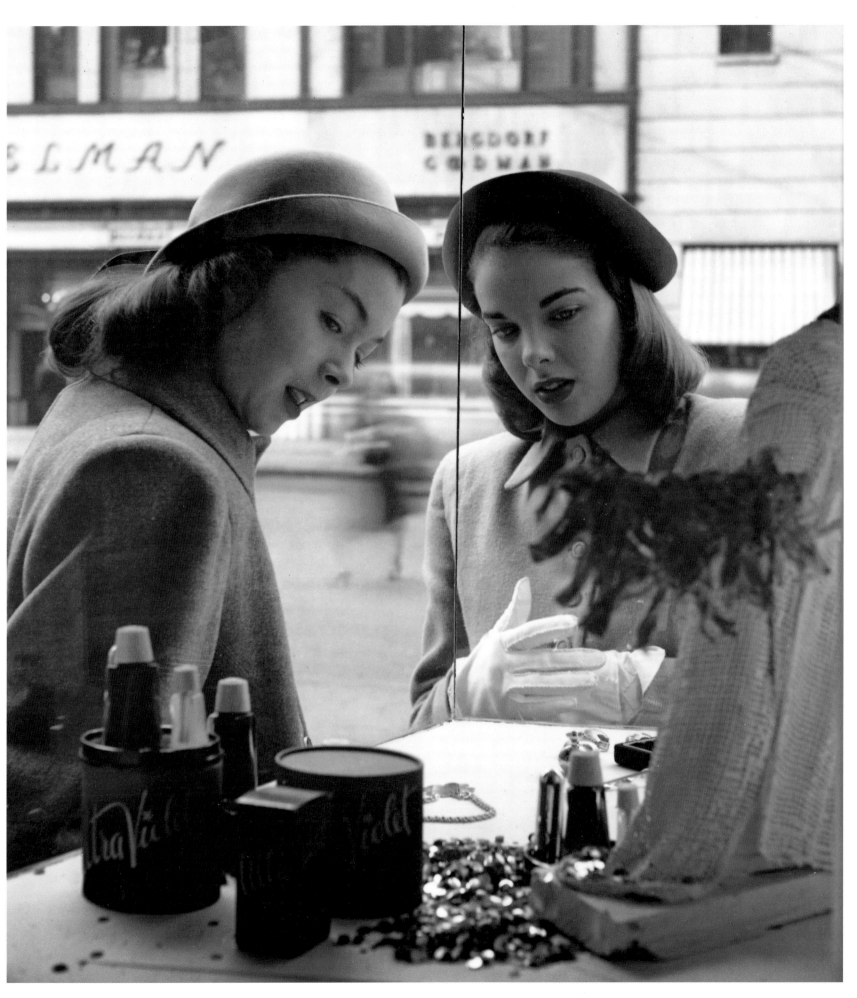

PAGE 78
Model Bernice Lipson, New York, 1940s

PAGE 79
Models window shopping, New York, 1940s

OPPOSITE
Producer Leland Hayward in his office with painting by Paul Klee, New York, 1948

PAGES 82–83
Producer Stanley Kramer in Spanish Harlem, New York, 1952

PAGE 84
Actor John Mills, Central Park, New York, late 1952

PAGE 85
Composer and playwright Gian Carlo Menotti, New York, 1947

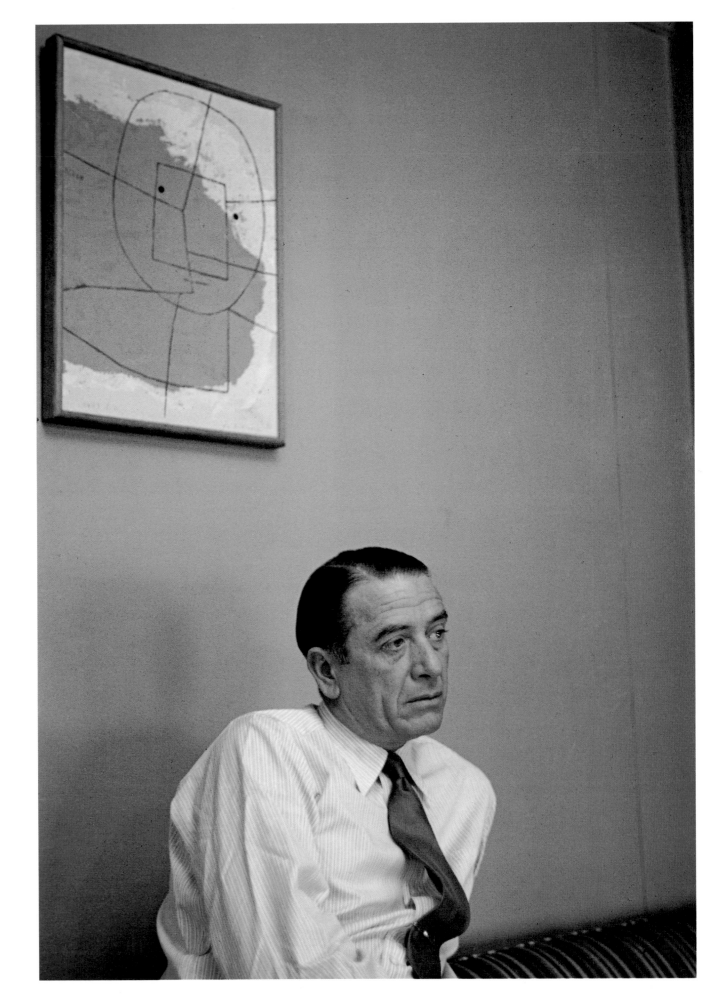

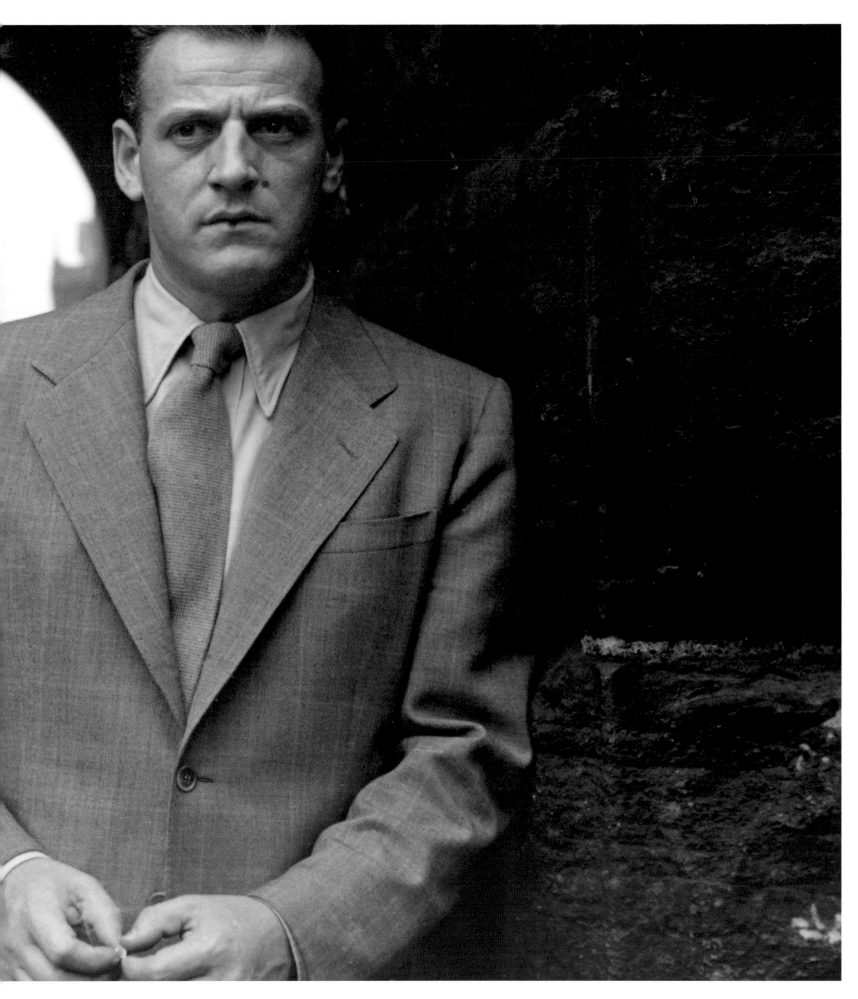

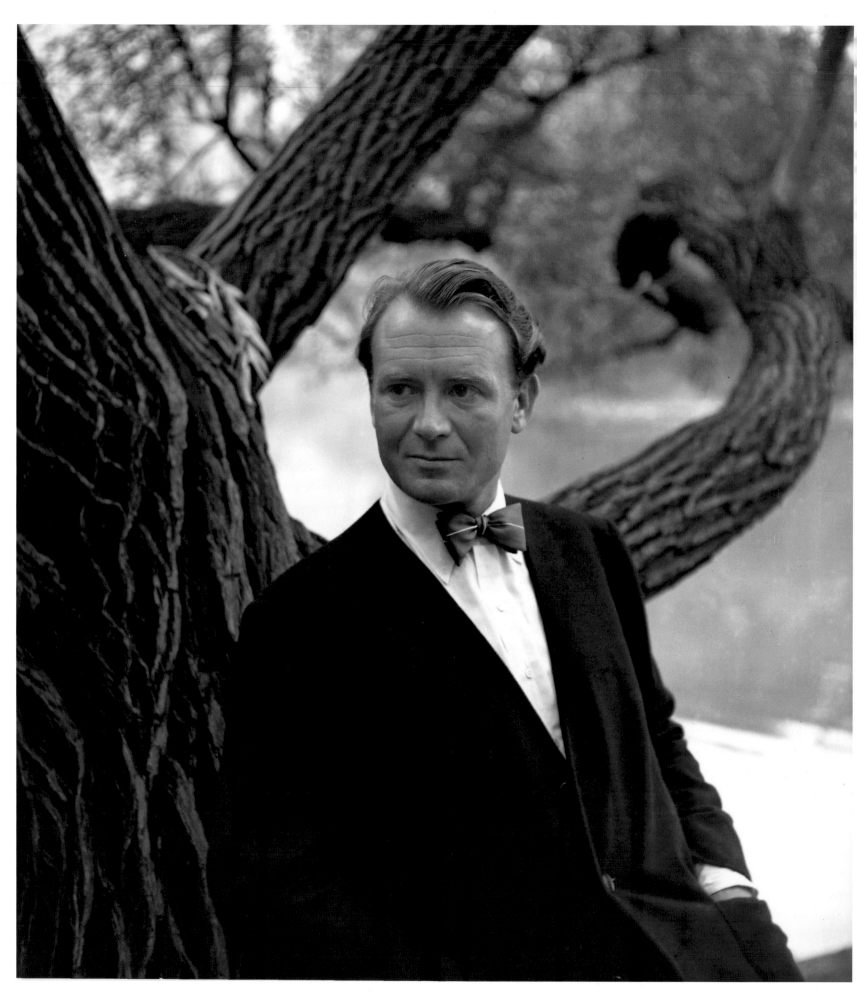

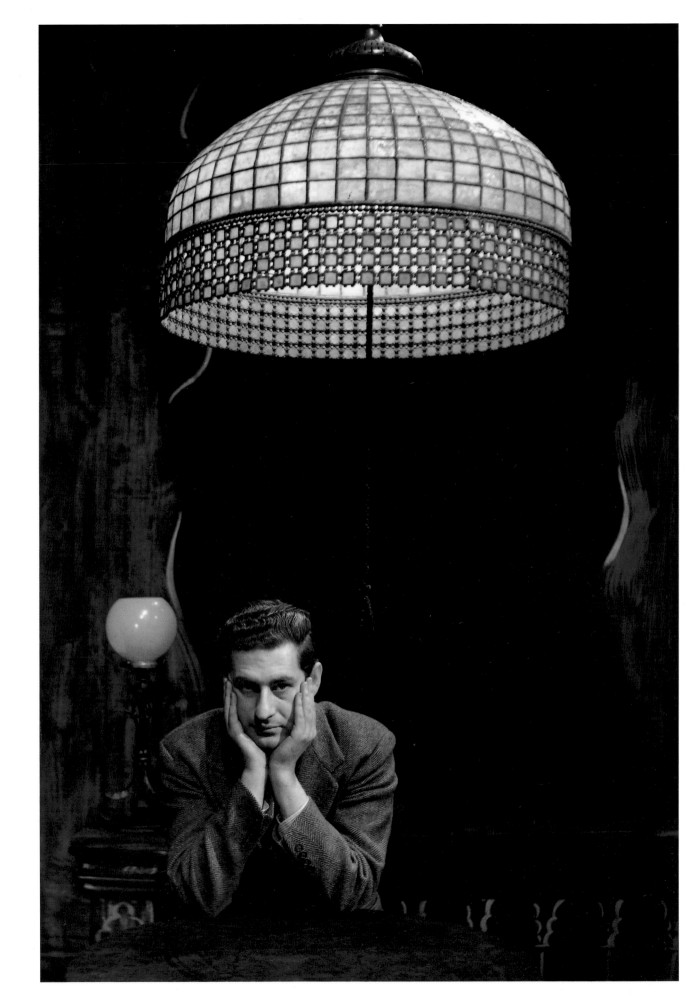

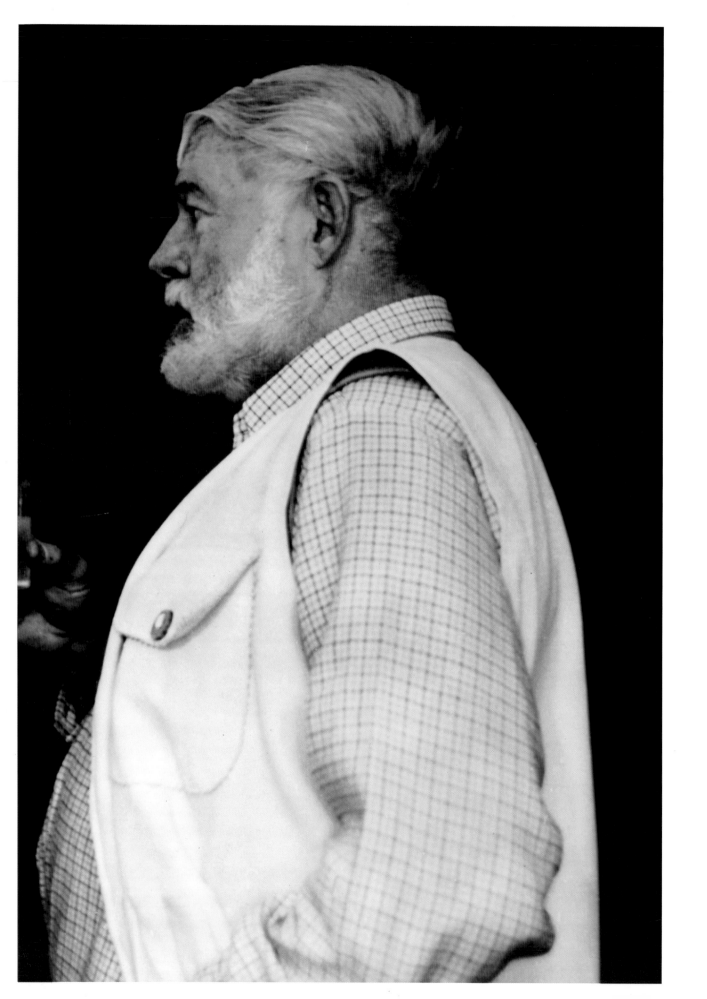

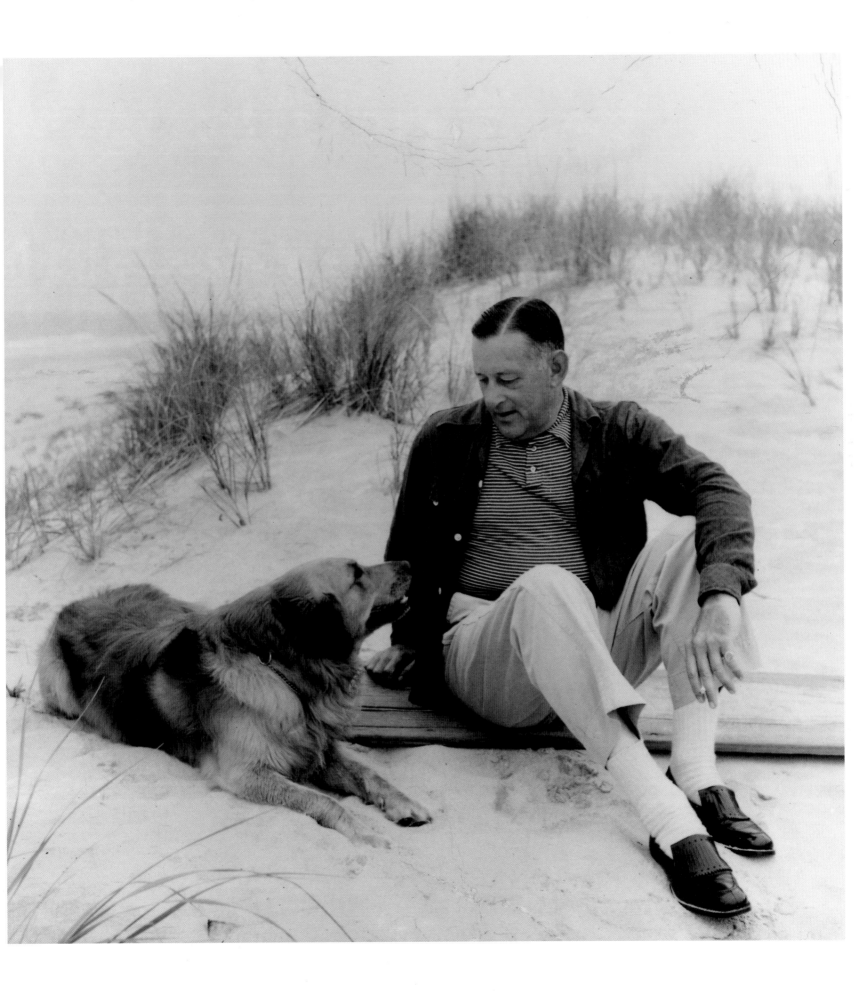

PAGE 86
Author Ernest Hemingway, Ketchum, Idaho, 1959

PAGE 87
Author John O'Hara, Quogue, New York, 1950s

OPPOSITE
Actress Lauren Bacall, Dior showroom, Paris, 1960s

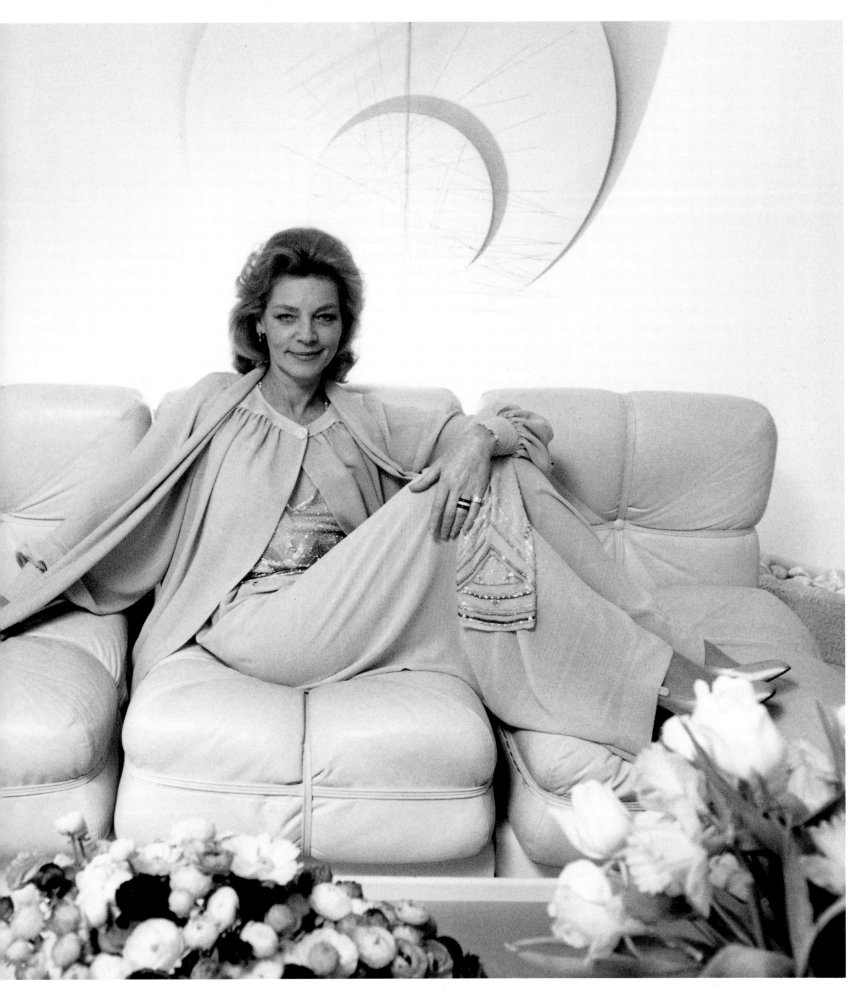

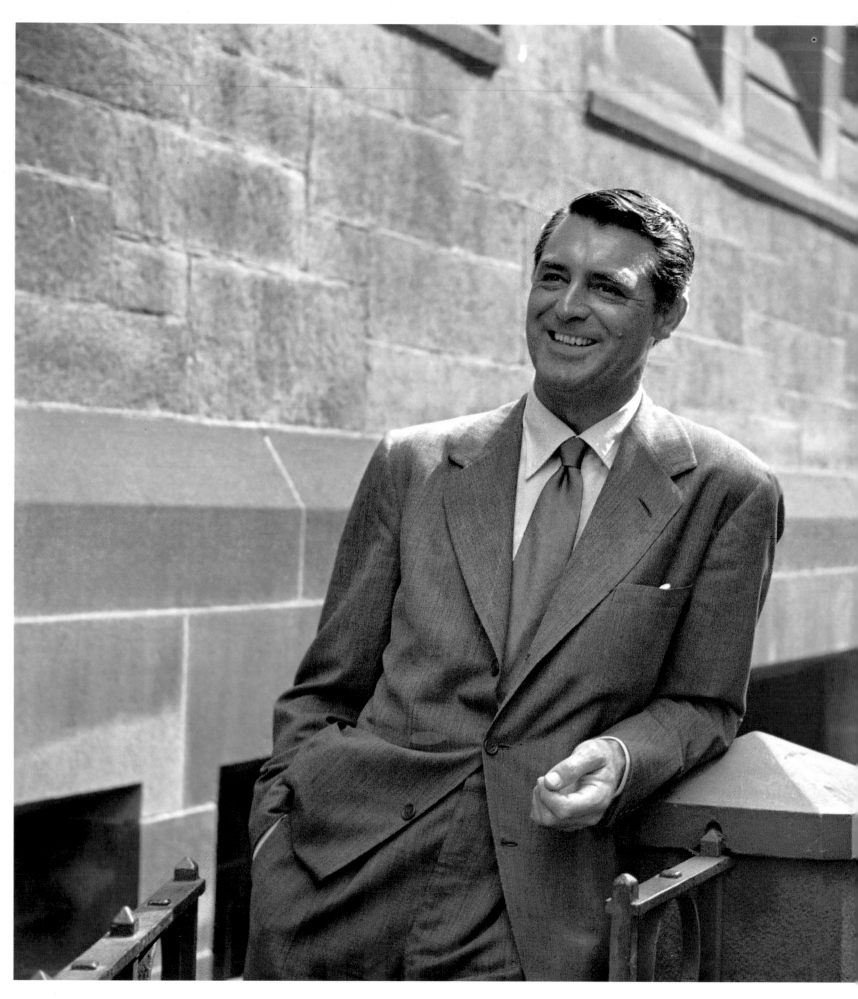

Cary Grant , New York, 1940s

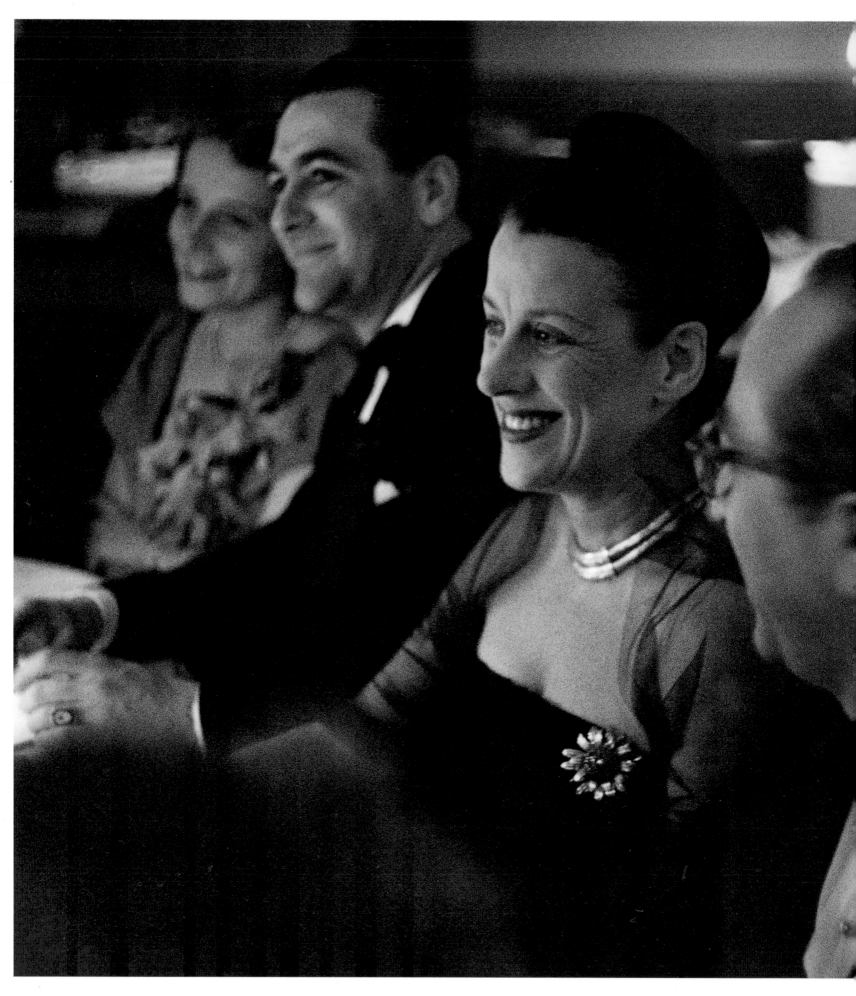

OPPOSITE
Entertainer Beatrice Lillie, New York, 1950s

PAGE 94
Singer and actress Libby Holman, New York, 1947

PAGE 95
Model, New York, 1940s

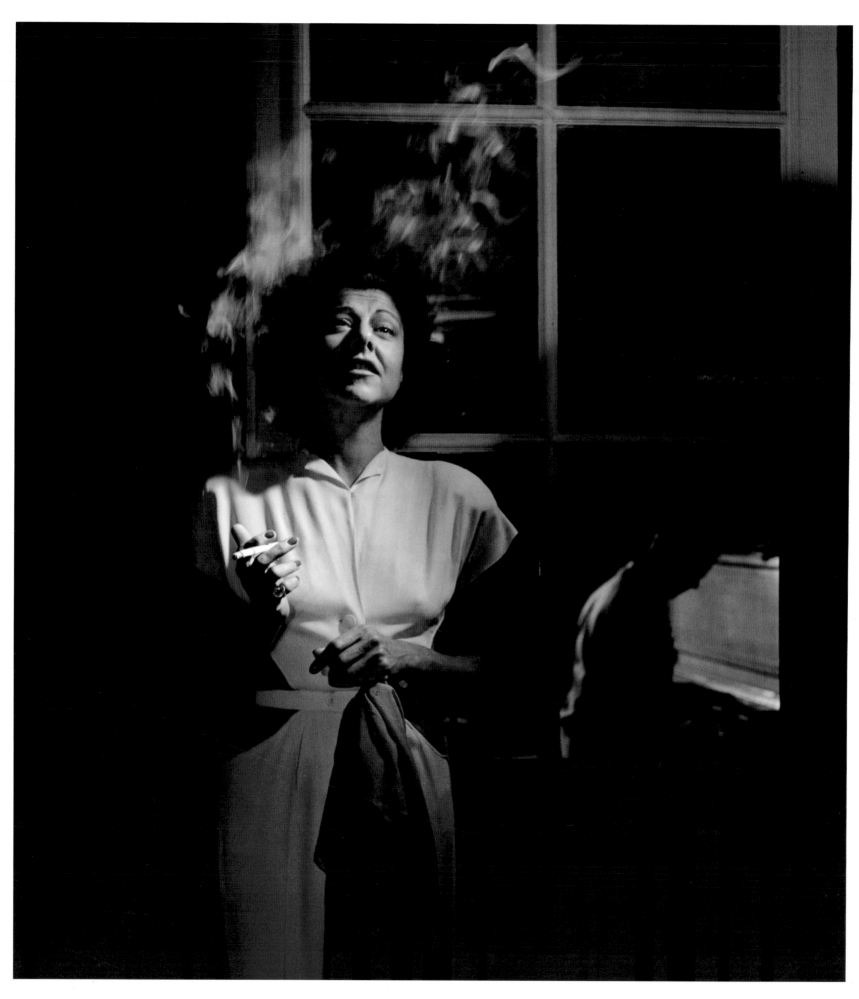

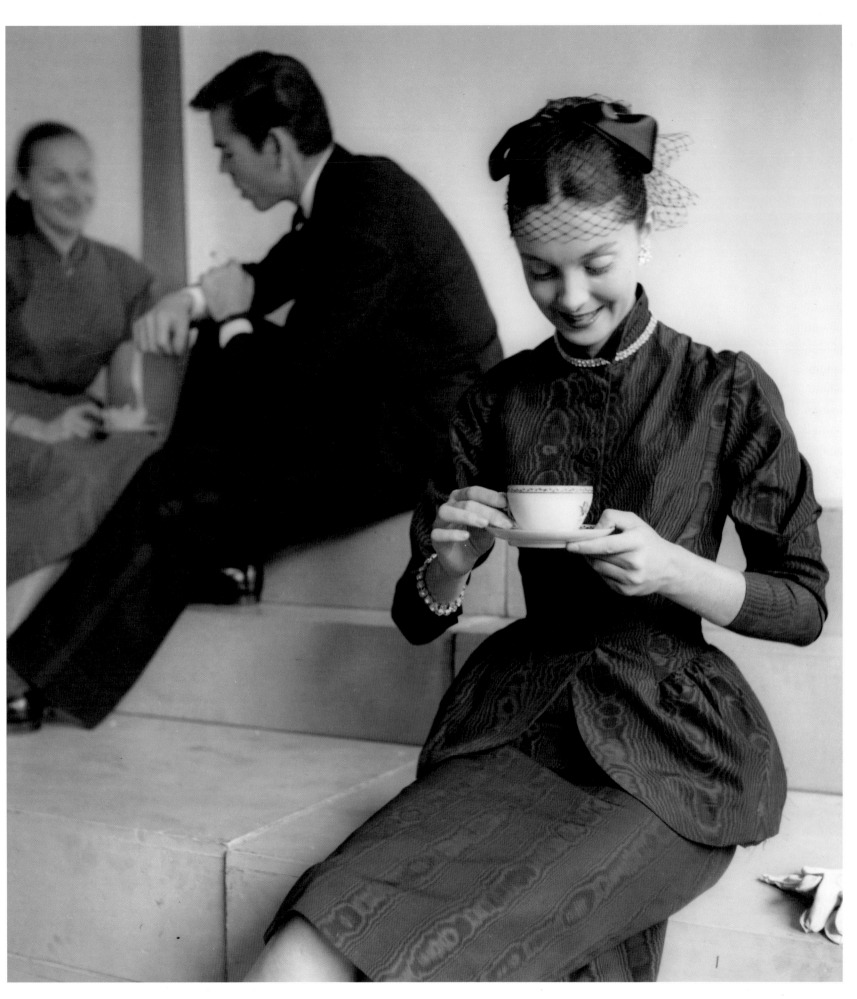

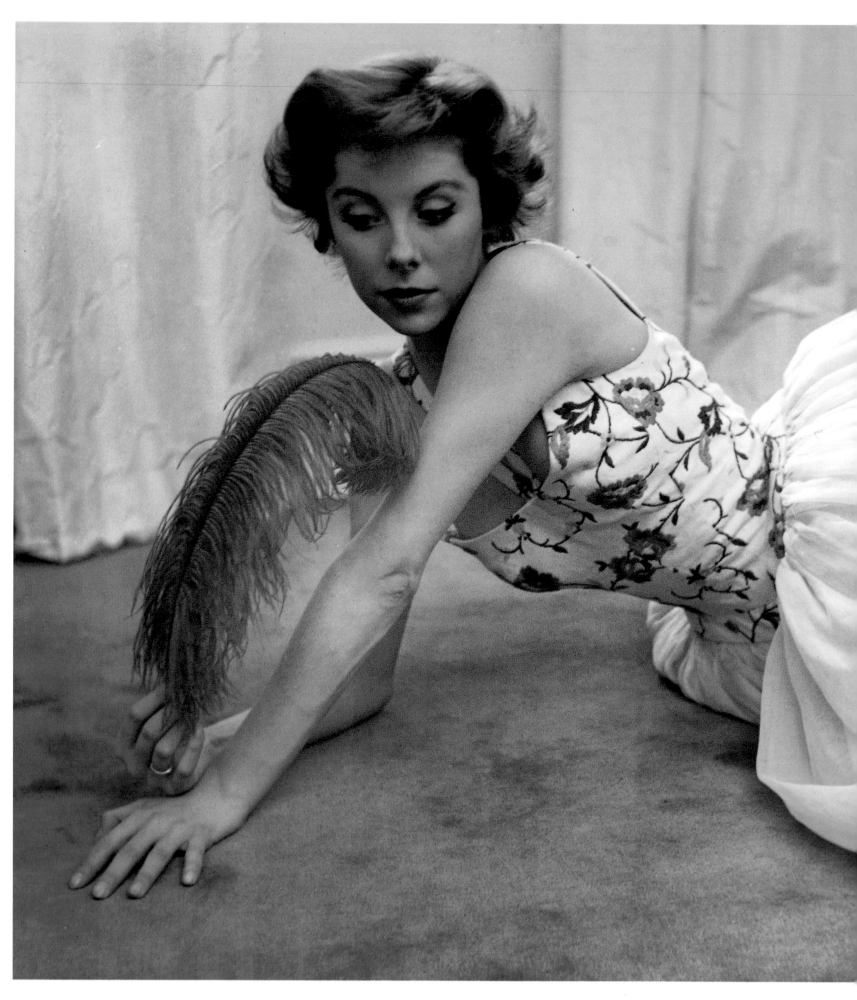

Actress Betsy von Furstenberg, New York, 1950s

OPPOSITE
Model, 1950s

PAGE 100
Wedding, 1950s

PAGE 101
Model, New York, 1940s

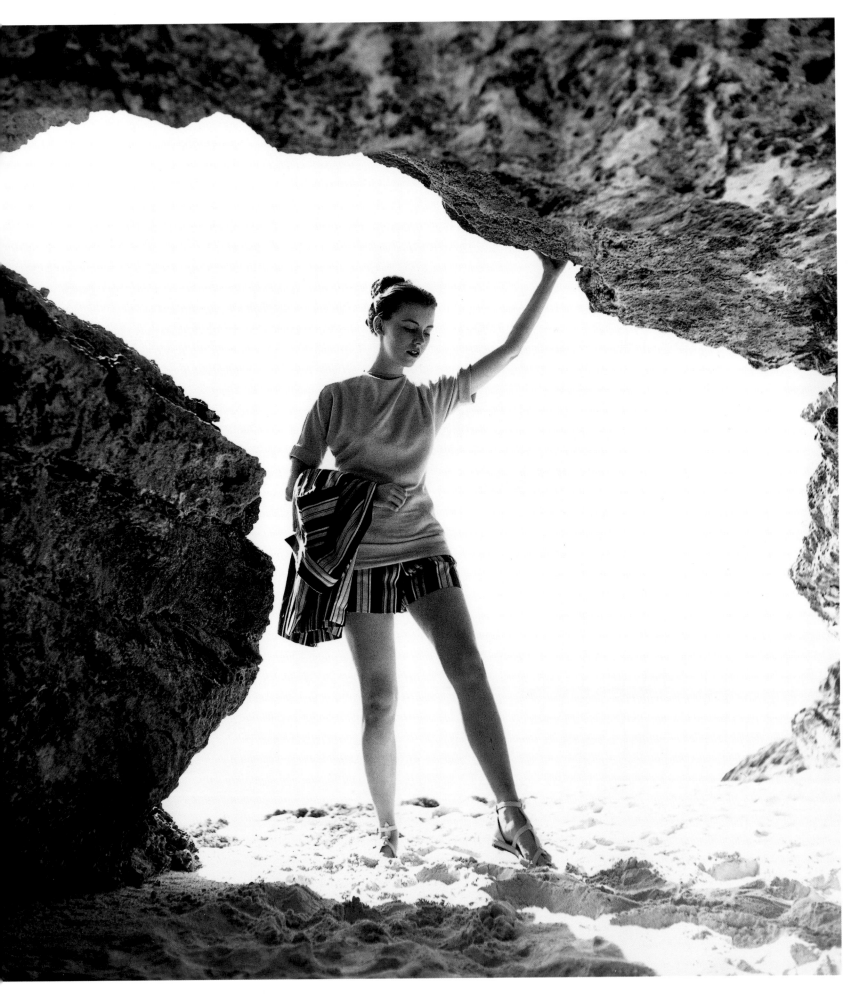

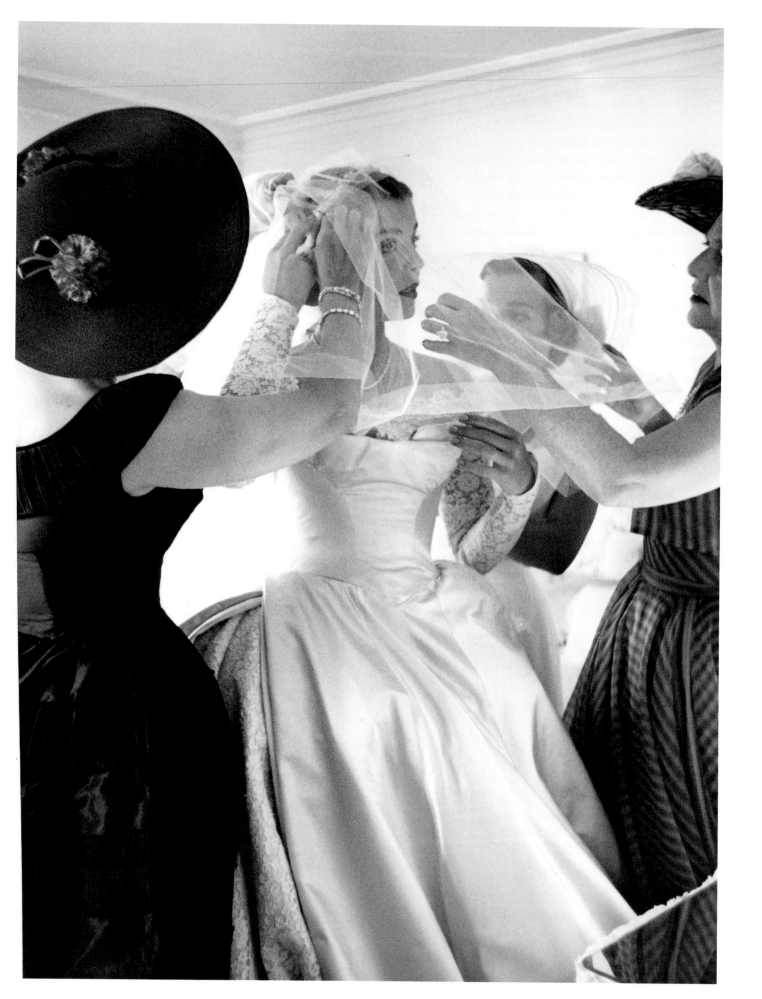

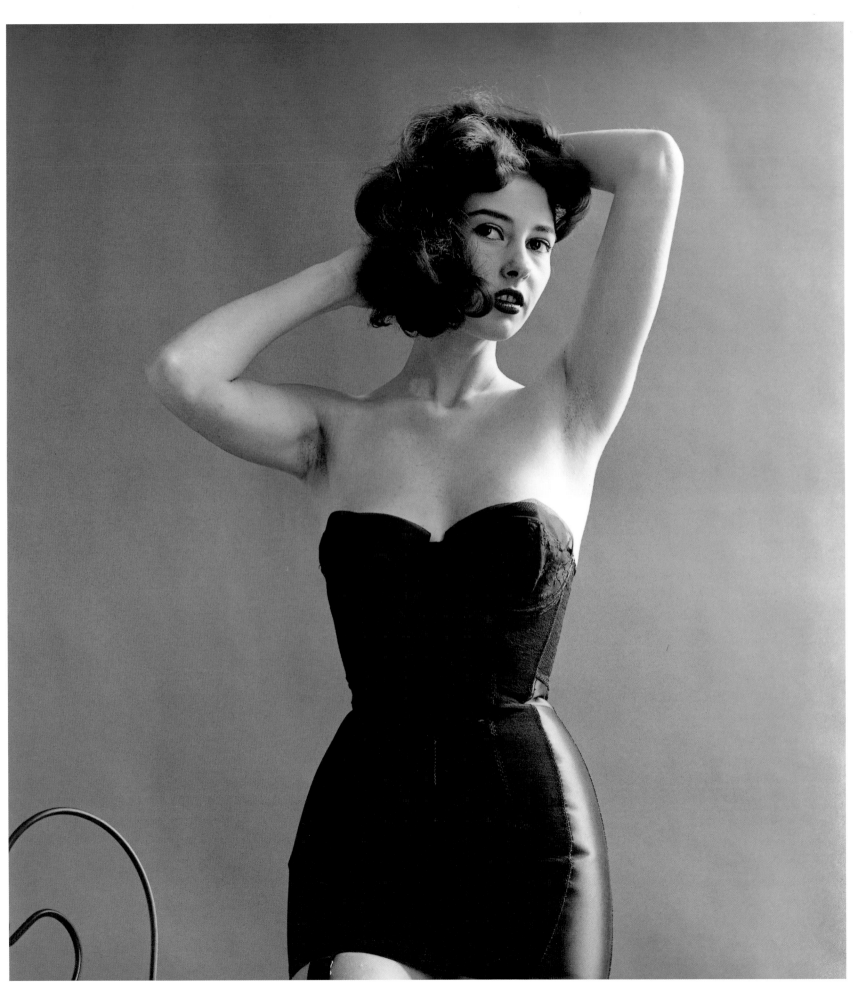

OPPOSITE
Model, New York, 1940s

PAGE 104
Actor Sam Wanamaker, New York, 1950s

PAGE 105
Actress Deborah Kerr and her first husband, Anthony Bartley,
Central Park, New York, 1950s

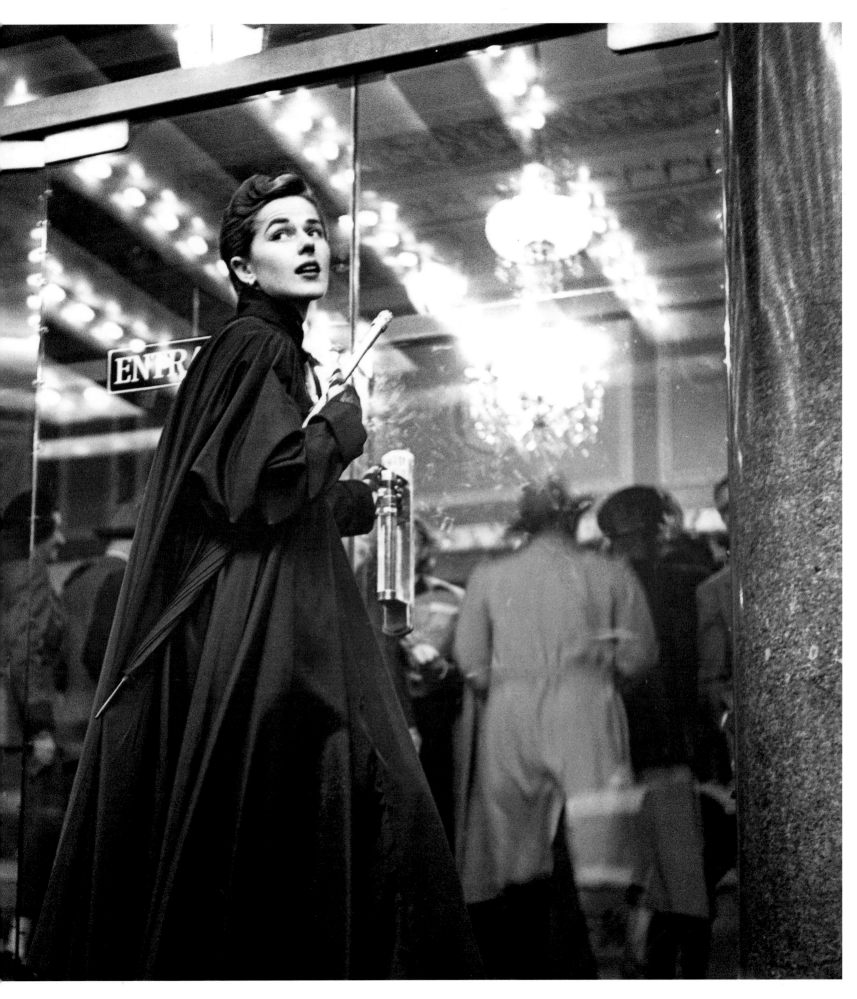

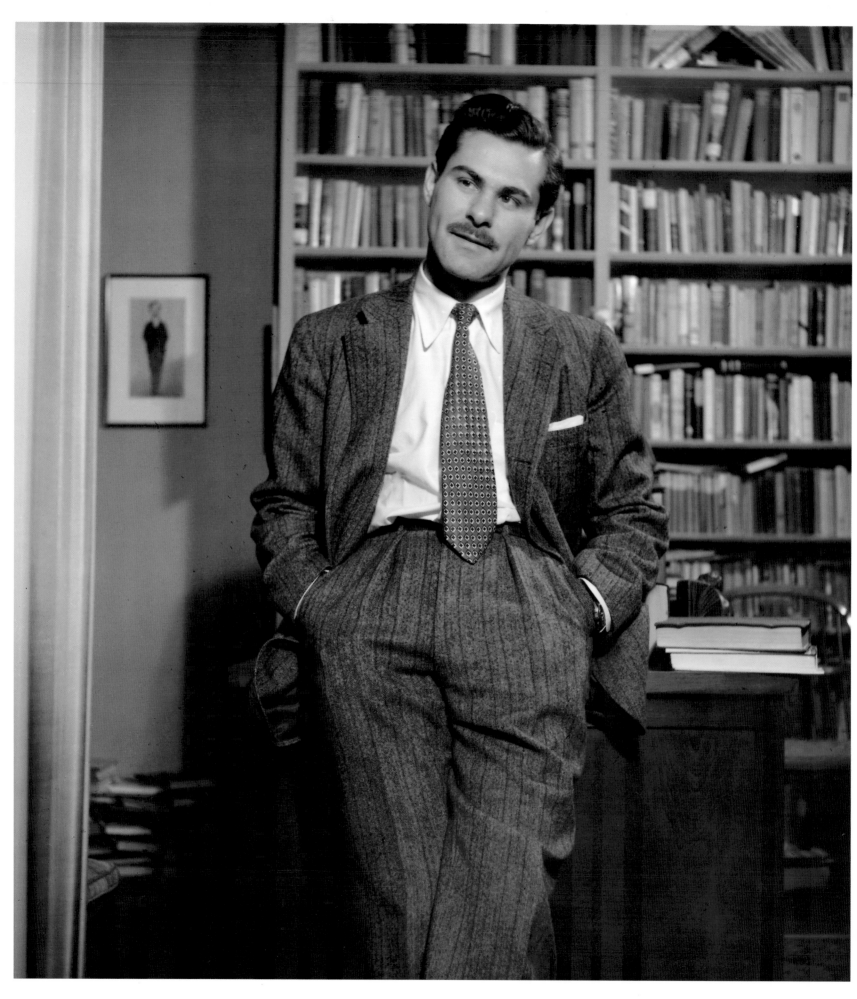

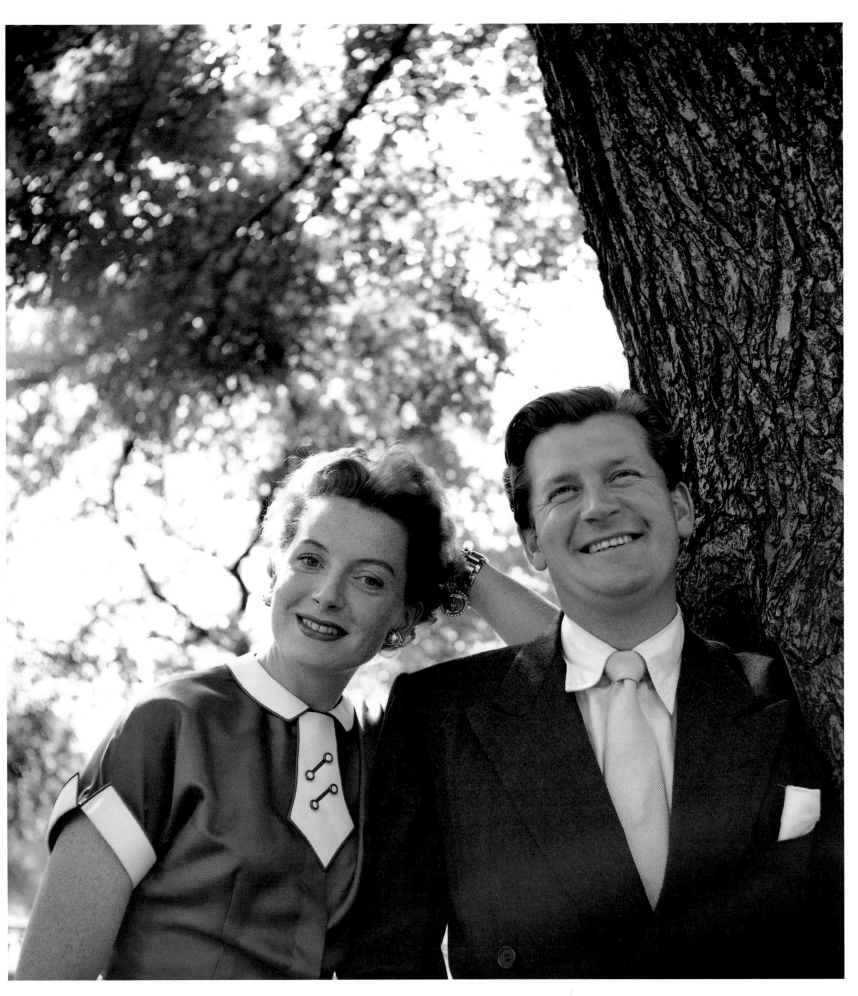

OPPOSITE
Silent-screen actress Pola Negri with portrait of her paramour, actor Rudolph Valentino, 1940s

PAGE 108
Lilly and Peter Pulitzer, Lantana, Florida, 1953

PAGE 109
Claudia Street aboard SS *United States*, 1952

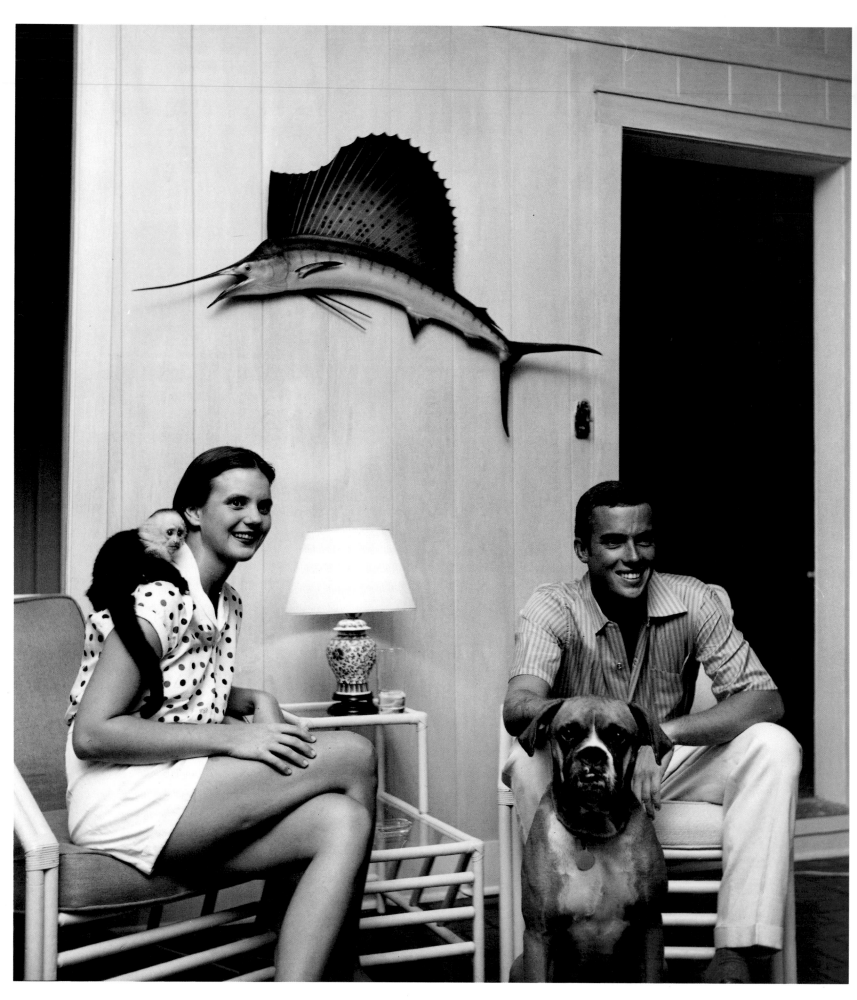

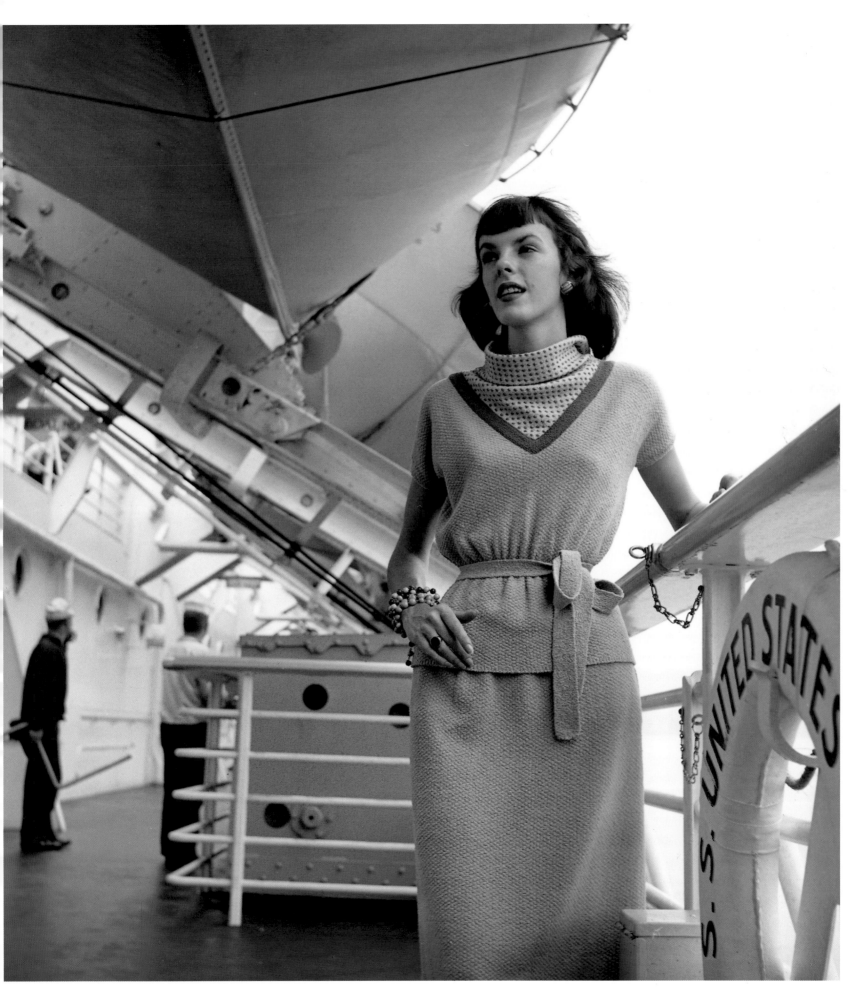

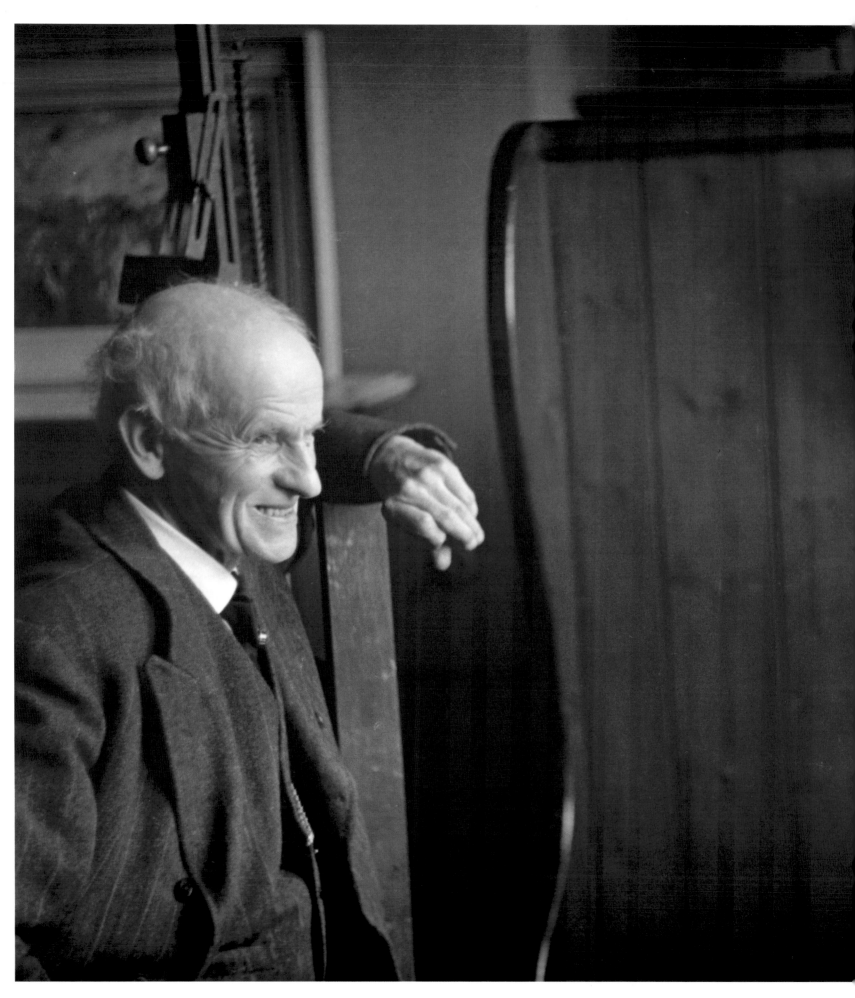

Artist Jack Butler Yeats in his studio,
Dublin, Ireland, 1948

OPPOSITE
Irish writer Dr. E. OE. Somerville, County Cork, Ireland, 1948

PAGE 114
Actor Clifton Webb, on the set of a play, New York, 1949

PAGE 115
Vicomtesse Jacqueline de Ribes, New York, 1950s

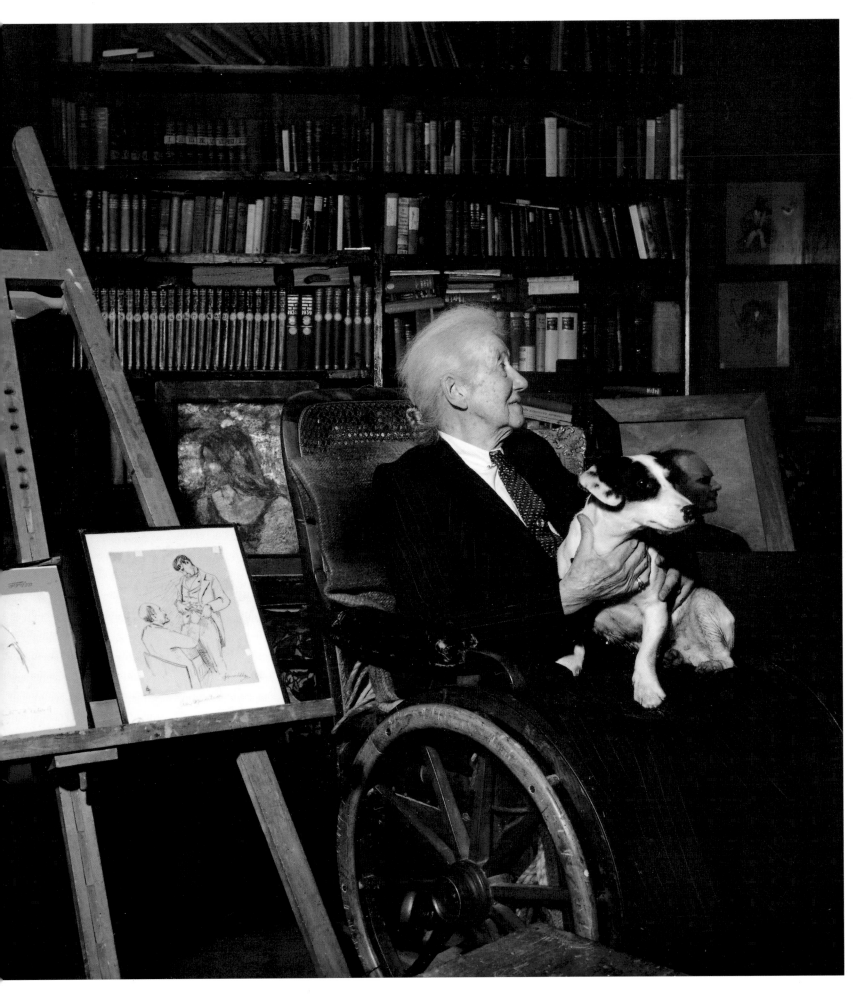

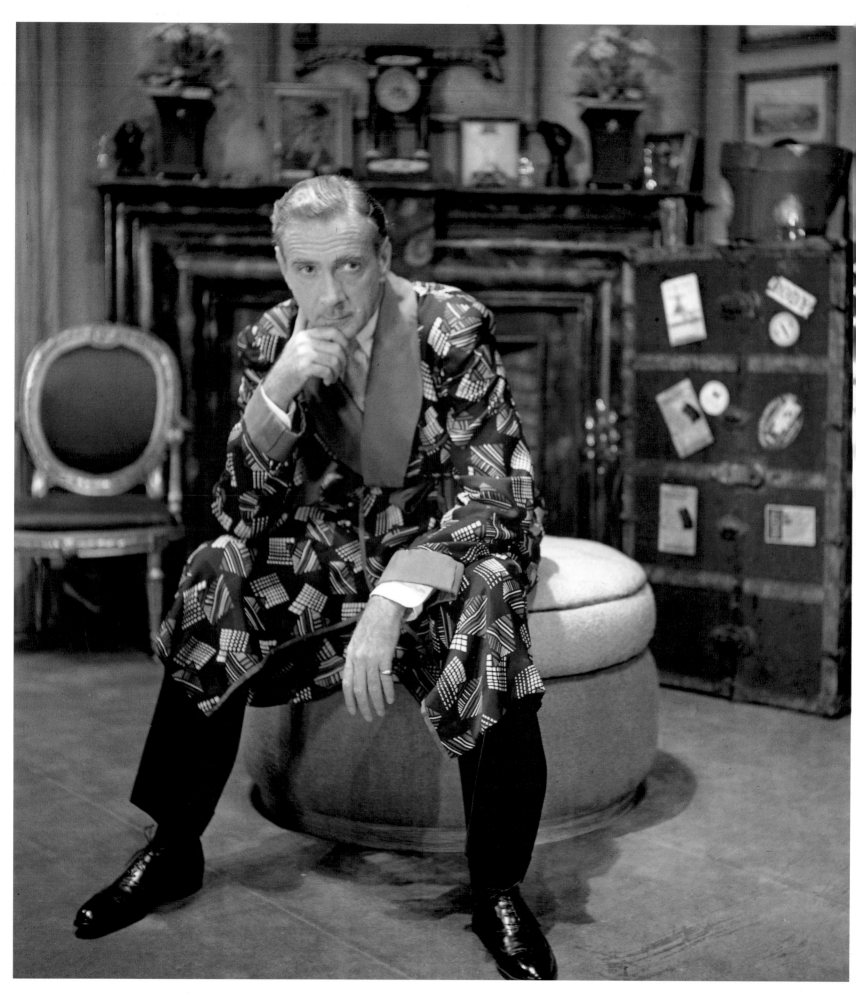

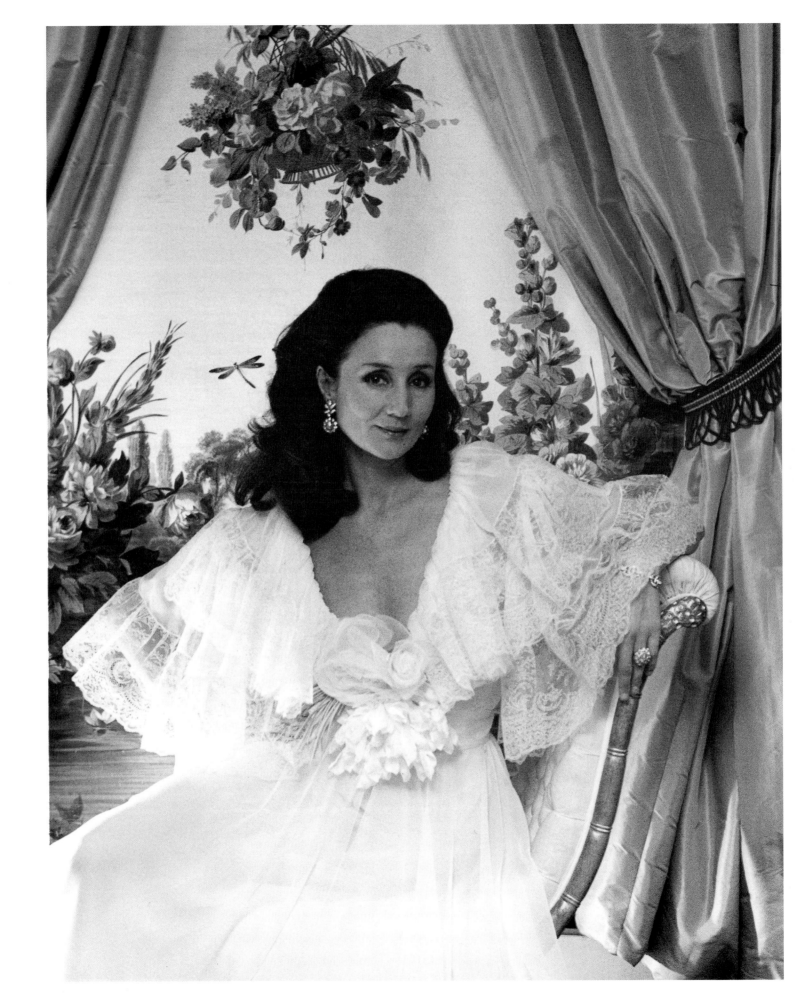

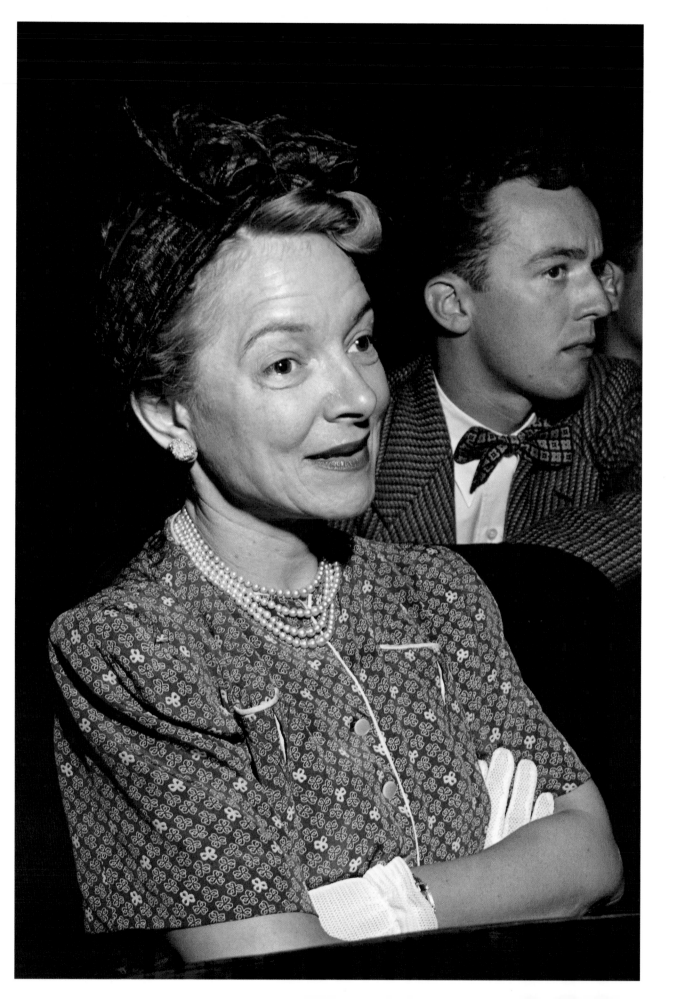

PAGE 116
Actress Helen Hayes watching a rehearsal, New York, 1940s

PAGE 117
Actor Mel Ferrer, Montreal, Canada, 1945

OPPOSITE
Actor, director and producer John Houseman, New York, 1949

OPPOSITE
Singers Mary Martin and Ezio Pinza rehearsing the score from
South Pacific with composer Richard Rodgers, 1949

PAGE 122
Poet Stephen Spender, New York, 1948

PAGE 123
Fashion designer Gabrielle "Coco" Chanel, Lausanne, Switzerland, 1969

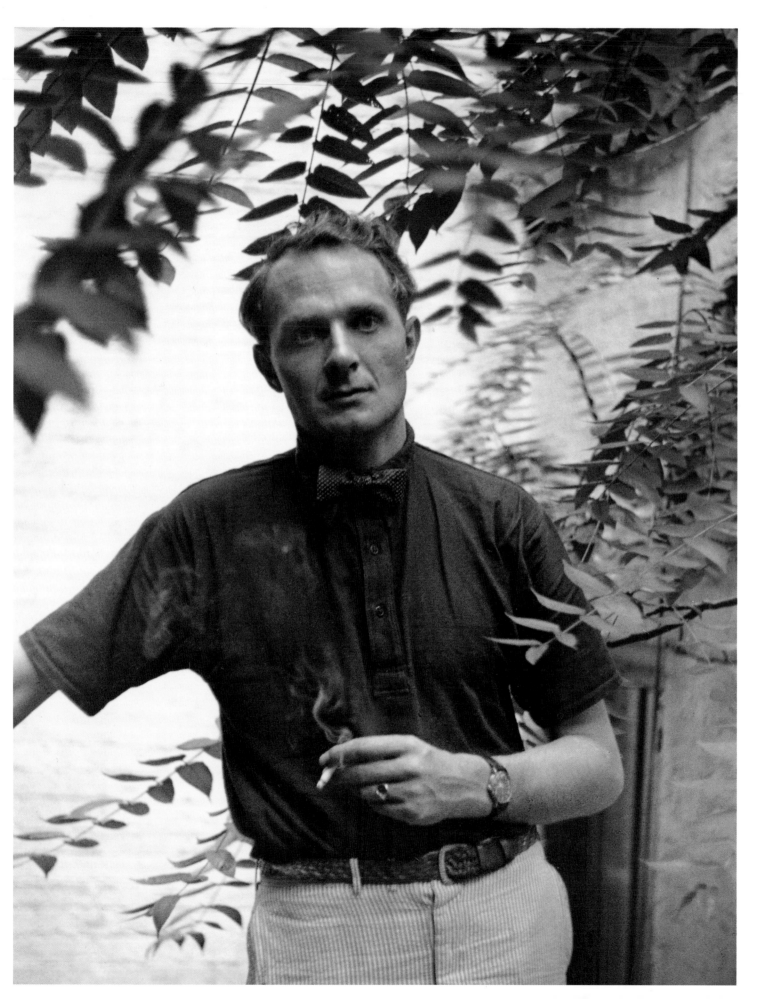

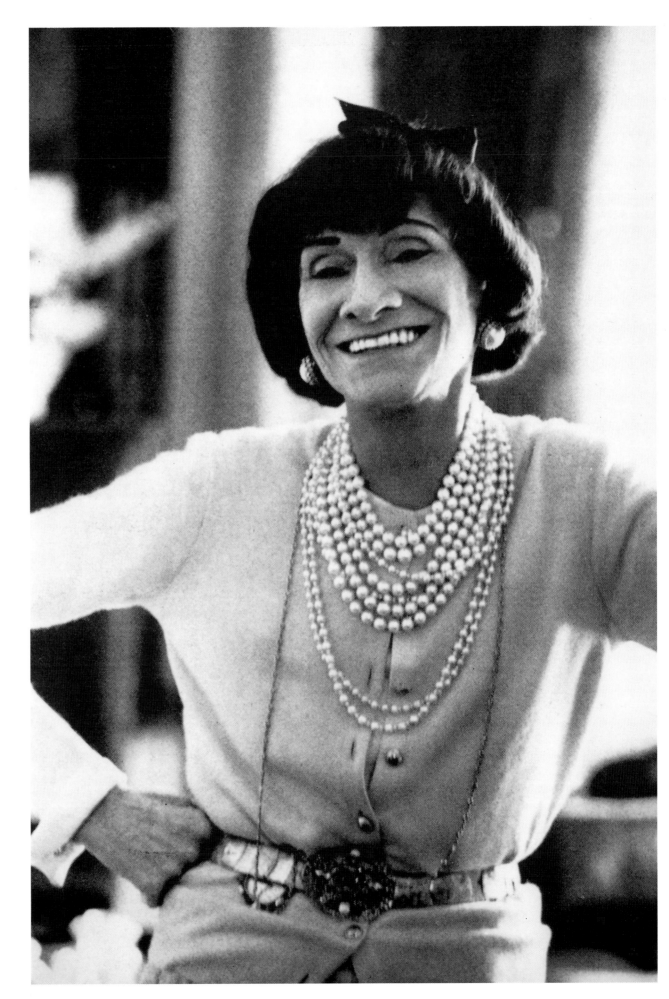

Poet W. H. Auden, New York, 1948

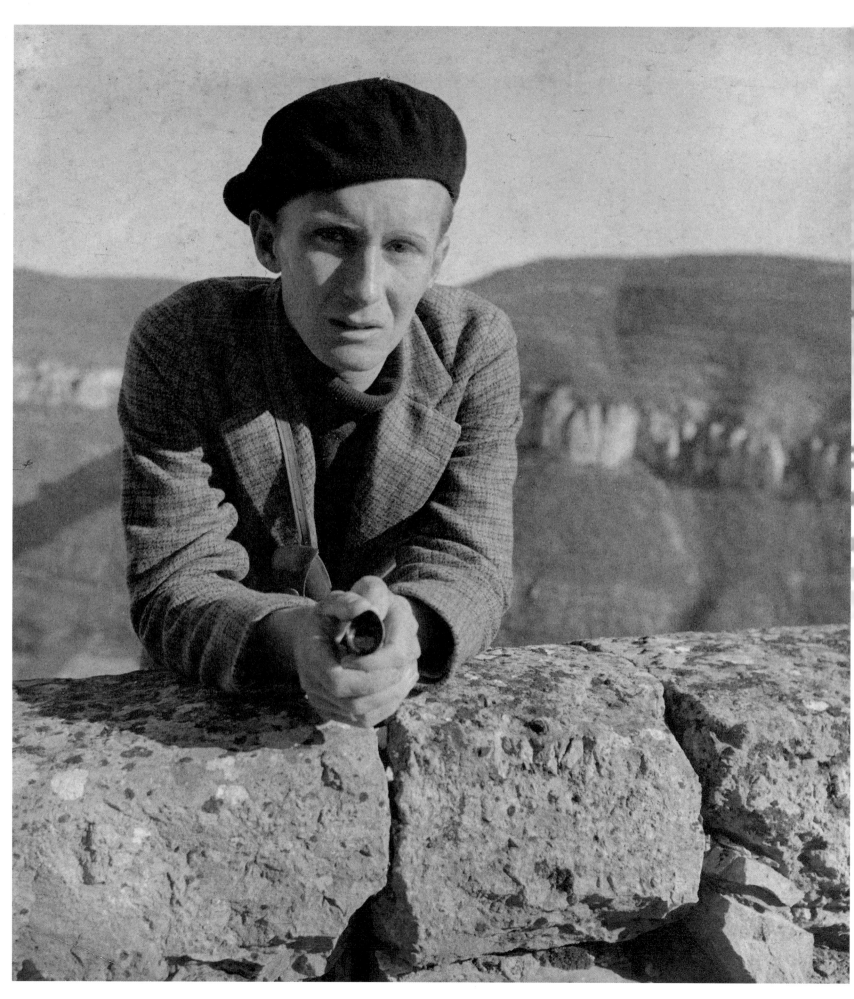

Ronny Jaques, France, 1934

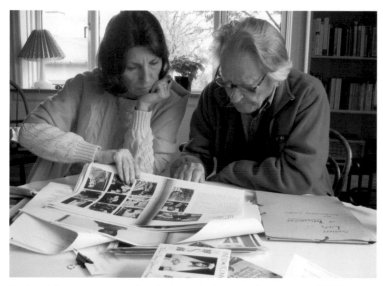

Fiori and Jaques pore over the photographer's work, Copenhagen, 2007.

No book is a solo act, and this one is no exception. Mary Shanahan and I want to thank the following people for adding so enormously to the effort:

First, to Lise Valeur-Jaques, Ronny's wife, and to their son, Jens-Louis, for their unwavering enthusiasm from the start. To Ronny's longtime friends and admirers, Cynthia Matthews, Jon Carson, Zanne Stewart and Anthony Mazzola for sharing their memories.

Glenda Bailey, editor in chief of *Harper's Bazaar,* and Norma Stevens, executive director of the Richard Avedon Foundation, who generously allowed us access to their archives.

Helping on the design and research end were Agnethe Glatved, Frank Augugliaro, Kerry Durkin, Stephanie Green, Linda Crowley and Rebecca Iovan.

Finally, we want to thank our publisher, Marta Hallett, who right away recognized the significance of Ronny Jaques's work and knew that it was a book that was meant to be (and now is).

PAMELA FIORI